D1587014

BRENT LIBRARIES

Please return/renew this item
by the last date shown.
Books may also be renewed by
phone or online.
Tel: 0115 929 3388
On-line www.brent.gov.uk/libraryservice

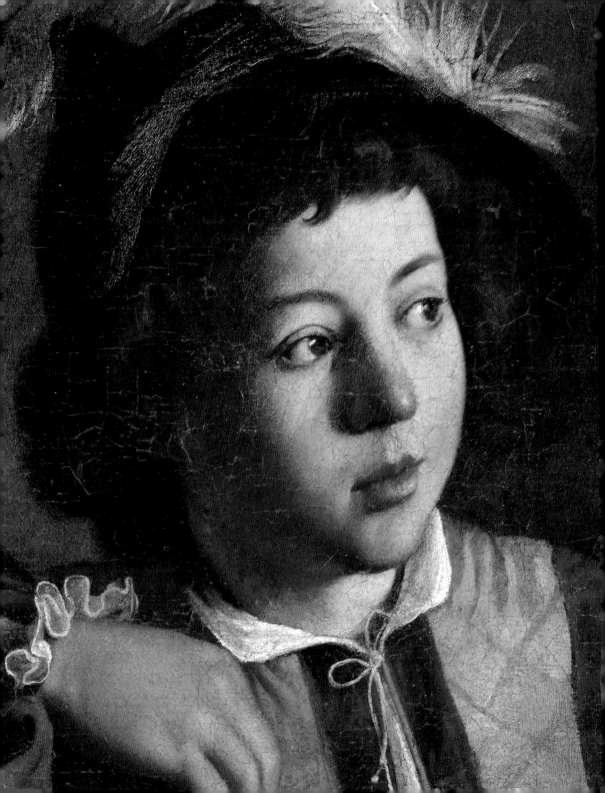

Masters of Art

Caravaggio

Stefano Zuffi

PRESTEL

Munich · London · New York

Front cover: *Love Victorious*, 1601–1602, Gemäldegalerie, Berlin (detail), see page 85
Frontispiece: *The Calling of St. Matthew*, 1599–1600, San Luigi dei Francesi, Rome (detail), see page 73
Back cover: *Still Life with a Basket of Fruit*, 1597–1598, Pinacoteca Ambrosiana, Milan (detail), see page 61

© Prestel Verlag, Munich · London · New York, 2012
© Mondadori Electa SpA, 2007 (Italian edition)

British Library Cataloguing-in Publication Data: a catalogue record for this book is available
from the British Library; Deutsche Nationalbibliothek holds a record of this publication in the Deutsche
Nationalbibliografie; detailed bibliographical data can be found under: http://dnb.d-nb.de

The Library of Congress Number: 2011942812

Prestel Verlag, Munich
A member of Verlagsgruppe Random House GmbH

Prestel Verlag
Neumarkter Strasse 28
81673 Munich
Tel. +49(0)89 4136 0
Fax +49(0)89 4136 2335

www.prestel.de

Prestel Publishing Ltd.
4 Bloomsbury Place
London WC1A 2QA
Tel. +44 (0)20 7323-5004
Fax +44 (0)20 7636-8004

Prestel Publishing
900 Broadway, Suite 603
New York, NY 10003
Tel. +1 (212) 995-2720
Fax +1 (212) 995-2733

www.prestel.com

Prestel books are available worldwide. Please contact your nearest bookseller or
one of the above addresses for information concerning your local distributor.

Editorial direction: Claudia Stäuble, assisted by Franziska Stegmann
Translation from German: Kathryn O'Donoghue
Copyediting: Chris Murray
Production: Astrid Wedemeyer
Typesetting: Andrea Mogwitz, Munich
Cover: Sofarobotnik, Augsburg & Munich
Printing and binding: Mondadori Printing, Verona, Italy

FSC
www.fsc.org
MIX
Papier aus ver-
antwortungsvollen
Quellen
FSC® C018290

ISBN 978-3-7913-4656-4

Contents

Introduction

With Caravaggio it is difficult to draw a clear distinction between art and life. The chiaroscuro of beauty and violence, genius and crime, permeates everything he did. Those who wrote about Caravaggio in his own day found it difficult to conceal their unease with a man who was famous as an artist and infamous as a flagrant sinner and criminal. Even his lonely death on the shore of the Tyrrhenian Sea under the searing July sun in 1610 may have seemed to many to be divine retribution for a misspent life. Today we are more reluctant to allow his failings as a man to adversely influence our response to his art. In the seventeenth century it was scandalous that the hand that painted poignant Madonnas and transcendent angels on canvas was also stained with the blood of another man. For us, however, it is the very contradictions in Caravaggio, one of the greatest painters of all time, that act as a key to a full understanding of him as an artist and a man.

Caravaggio leaves us no choice: he touches us, forces us to take sides. In each painting he makes us an eye-witness to an event. He presents us with the gaping chasm between the human and the divine. The reality of his pictures draws us in a way that we cannot resist.

None of the Old Masters speak to the modern viewer as directly and forcefully as Caravaggio. Viewing his images, we seem to be seeing not a depiction of an event but the event itself, taking place here and now. Caravaggio's works are one thing above all else: truthful. He believed in what he was painting— to the extent that he often appears in the scenes himself, taking the place of one of the actors. Life and art overlap and penetrate in his work in a way that is almost unique.

Like all great artists, Caravaggio possessed characteristic technical and stylistic abilities that make his creations very distinctive. He had a highly developed ability to appropriate the imagery others had formulated before him and to make it entirely his own: Leonardo, Titian, the realists of the Lombardy School in particular, as well as Michelangelo, his great inspiration, whose work he encountered wherever he went in Rome. The style he fashioned from these influences allowed him both to satisfy the wishes of the Roman collectors and, at the same time, to exercise astonishing freedom in the interpretation of traditional religious themes, which he saw in terms of an unerring view of reality. What differentiates Caravaggio from all painters before him is the overwhelming power of his images to make the scenes he depicted become

reality in the eye of the viewer. This no longer had anything to do with the playful and highly sophisticated Mannerist art of his time.

It is probably because of the unreservedness with which Caravaggio faced life, and then captured that intense life so vividly in his art, that many of his pictures, which are today considered to be masterpieces of European painting, were removed from the alters and churches for which they were intended, and exhibited in the private collections of the rich *cognoscenti*. Caravaggio's fame was based on these "art scandals."

Caravaggio moved in exalted circles, keeping company with the Papal Curia in the palaces of Rome, with princes in Genoa, and with the aristocratic Knights of St. John on Malta. But he also enjoyed life in the taverns, got to know prisons and dungeons from the inside, and was at home in the alleys and backstreets of many Italian cities, from Rome and Naples to Syracuse, Messina, and Palermo. It is this world that he brings to the stage in his pictures, with changing actors and always from new perspectives. Even if the scenes he "enacts" are taken from the canon of classical themes in painting, Caravaggio's dramaturgy is new and realistic in an unprecedented way. It never leaves the observer indifferent. In this context, he has something in common with another genius from the seventeenth century: William Shakespeare.

Stefano Zuffi

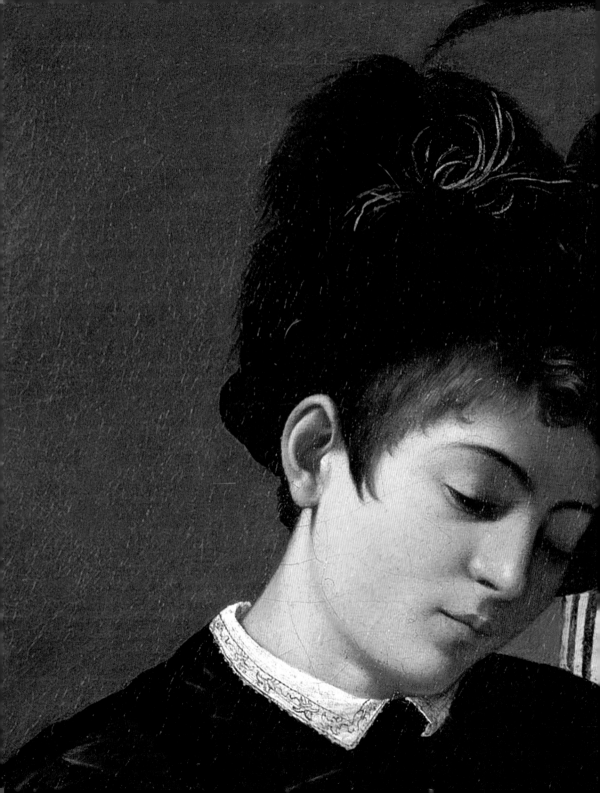

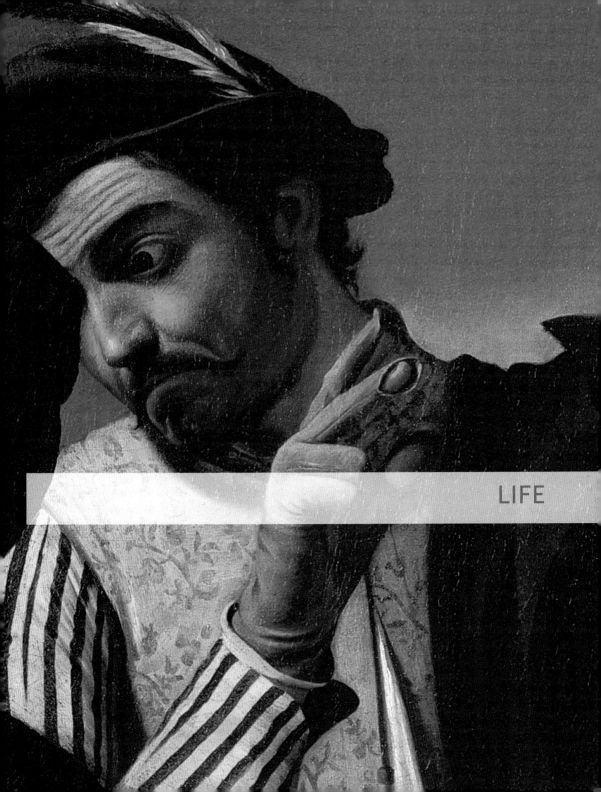

LIFE

Caravaggio: A Genius on the Run

Caravaggio only once signed one of his paintings. The picture depicts the scene of a beheading; the beheaded man lies stretched out on the ground, blood running from his neck. The artist wrote his name in this blood, the signature of an artist whose dramatic life unfolded in Milan and Rome, Genoa and Naples, Sicily and Malta. Its scenes were played out in magnificent palaces, shabby backstreets, shady taverns, and gloomy dungeons. And at the end of this picaresque life, there was the tragedy of a lonely death on a beach. Before this, however, in the two decades around 1600, Caravaggio created a body of work that was to give painting a new direction and to change profoundly the role of the observer in art.

Milan: the beginnings

Until a few years ago, it was assumed that Michelangelo Merisi—his true name—was born in the town of Caravaggio near Bergamo. However, recent research by a retired Milanese businessman in the archives of the Archdiocese of Milan has unearthed documents that prove that this assumption is not correct (as researchers had suspected for some time). There is an entry in the baptismal register of the parish of Santo Stefano in Brolo in Milan stating that the young Michelangelo was baptized on 30 September 1571, one day after his birth there. His father, the widower Fermo Merisi, had married Lucia Aratori on 14 January 1571. Michelangelo was her first

child; after him came two other brothers and a sister. The Merisis were middle-class. The father managed the estate and properties of the Marchese of Caravaggio, a small town near Bergamo, which was well known in those days for a shrine to the Virgin Mary that attracted countless pilgrims. Merisi's wife Lucia came from Caravaggio and one can assume that the young Michelangelo spent time in both Milan and in the country as he grew up. In Rome he was subsequently named after the town in which he had spent his childhood.

The village of Caravaggio then lay near the border separating the domain of Milan from the mainland estates of Venice. By the end of the sixteenth century, however, little remained of the grandeur and magnificence of the Grand Duchy of Milan. Following the war against France, the Spanish had become the rulers of Lombardy, now one of the many provinces in the huge empire of Charles V and his successor Philip II of Spain. Life in Milan, the region's capital, saw great changes. The days when Leonardo da Vinci staged magnificent festivities for the court of Ludovico Sforza (il Moro) in the Castello Sforzesco were long gone. Now a Spanish garrison was based in the city, which bristled with weapons and where life was closely controlled by government agents. It had become a fortress, surrounded by the "Spanish Walls," which stretched for 11 kilometers around the city. The Spanish Governor had taken up residence

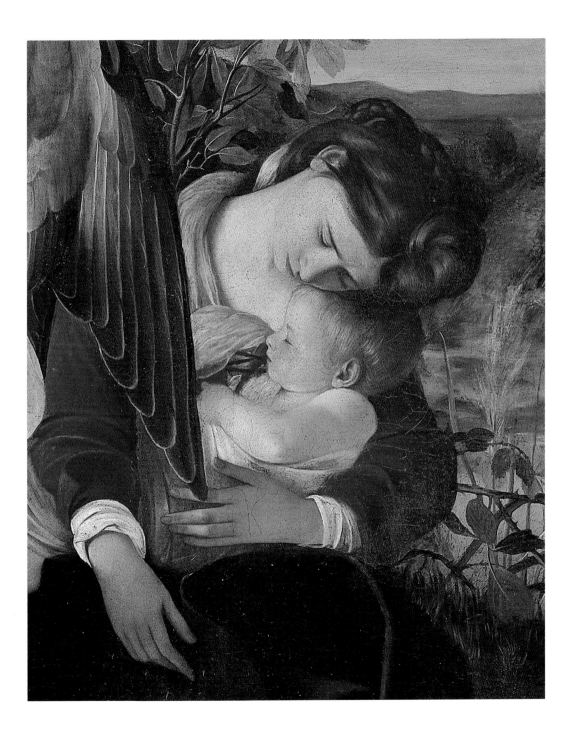

in the Visconti Palace, guarded by the garrison troops; when danger arose, he could barricade himself behind the walls of the Castello Sforzesco.

The reforms of Cardinal Borromeo

One person resolutely resisted the decline of Milan brought on by the Spanish rulers: Carlo Borromeo, who would become one of the greatest saints of the Counter Reformation. As the Archbishop of Milan, Carlo Borromeo, who was descended from northern Italian nobility, had more influence on the fate of the city in the second half of the sixteenth century than any other person. Several members of the Merisi family, including an uncle of Caravaggio's, were priests involved in the reforms of Borromeo, who was a determined supporter of anti-Spanish factions. Milan Cathedral, whose interior had been renovated in accordance with the liturgical rules of the Council of Trent drawn up by Borromeo himself, became the spiritual and moral center of the city, as well its cultural and social focus. The population considered the Archbishop to be the protector of Milanese tradition. During the Black Death of 1576, which caused tens of thousands to die, his popularity increased even further. One of the last victims of the plague was Caravaggio's father, who died when Michelangelo was just six years old.

The great Milanese plague of 1576 also left its mark on art. In many paintings the tone became more severe, the forms simpler. Borromeo recognized ecclesiastical painting as an instrument of Counter-Reformation propaganda and advocated the avoidance of the compositional and iconographic complexity of Mannerism. Instead, he wanted paintings to have an immediate effect on the spirit and to be readily understood by ordinary people. The church architecture the Archbishop commended was to avoid excessive decoration and to have austere, clearly structured façades. In contrast, Milanese secular architecture of the period was characterized by a more vibrant, dramatic architectural style; the Palazzo Marino (the modern-day Milan city hall), designed by Galeazzo Alessi, was opulently decorated with ornamental figures. Alessi also designed the magnificent façade of the church of Santa Maria presso San Celso, one of the earliest Milanese church buildings from the sixteenth century. Here there was a painting with which the young Caravaggio was obviously very familiar. Painted by Alessandro Bonvicino, known as Il Moretto, it shows the Conversion of St. Paul in an unusually realistic manner; the future Apostle lies on the ground, while above him stands the massive body of his piebald horse. This painting was clearly the model for Caravaggio's celebrated *Conversion of St. Paul* in the Cerasi chapel in the church of Santa Maria del Popolo in Rome. Alessandro Bonvicino came from Brescia, and a glance at the paintings from there clearly illustrates what is meant by the "Lombardy origins" of Caravaggio's realism.

Caravaggio's first teacher: Simone Peterzano

Caravaggio received his initial artistic training in the workshop of the Milanese painter Simone Peterzano, who was involved with the

decoration of numerous churches in the late Renaissance style of Mannerism. Peterzano's most famous works, the frescos in the chancel of the Carthusian church of Garegnano near Milan, show how he used a lively color palette inspired by Venetian art. It is highly probable that the master took his apprentice to Venice for an extended stay in the late 1580s, where Caravaggio possibly met the seventy-year-old Tintoretto, who was still working at the time. However, there were also important examples of Renaissance painting in Milan itself on which the young Caravaggio could train his eye. One such example was to be found in the Dominican church of Santa Maria delle Grazie, where Ludovico Sforza and his wife Beatrice d'Este were buried. There, over a side altar, hung Titian's *The Crowning with Thorns* (1545; Louvre, Paris), one of his most impressive works. No other Renaissance painting is as close to Caravaggio's works in its painterly style, in its use of light, and in its drama. The young Caravaggio must have studied Titian's altarpiece in great detail. The same is true of one of the most important works of the Renaissance: Leonardo's wall painting the *Last Supper* in the refectory of the adjacent convent. Here the young Caravaggio was able to learn a great deal about the depiction of human emotions, which for Leonardo represented the ultimate aim of art.

The Fortune Teller, 1596–1597, Musée du Louvre, Paris

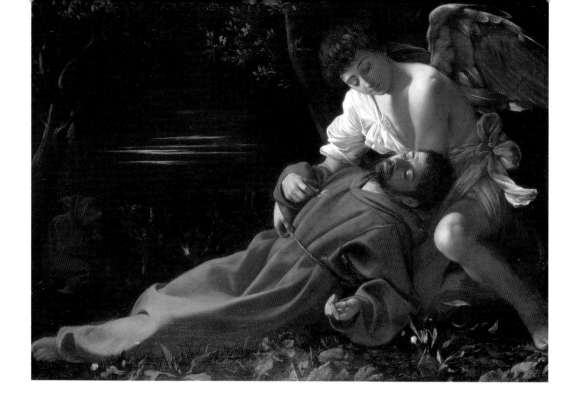

When his mother, Lucia Merisi, died on
29 November 1590, Caravaggio and his sib-
lings, who had moved back from Milan to Car-
avaggio several years before, shared the
modest inheritance. The future artist first had
to pay off some debts. He sold the small piece
of land remaining from his inheritance from
his mother as quickly as he could: obviously
a move to Rome was planned.

Caravaggio in the Eternal City

The precise details are unclear, but sometime
around 1592 Caravaggio, then twenty-one
years old, set off for Rome. He never returned
to Milan. For an artist from Lombardy looking
for work, Rome had great appeal. At the end
of the sixteenth century, the Papal City was
going through a process of huge architectural

and urban change. This *renovatio urbis*, which
was heralded by Pope Sixtus V, drew legions
of workers, builders, stonemasons, sculp-
tors, and representatives of many other
trades to the city. The scale of these under-
takings was colossal: basilicas dating from
late antiquity were restructured and expand-
ed, the grandiose rebuilding of St. Peters was
continued, new palaces and roads were built,
and giant Egyptian obelisks were erected, the
largest in the center of St. Peter's Square. This
was a feat of technical engineering accom-
plished by the pope's favorite architect,
Domenico Fontana, who came from the Swiss
canton of Ticino. During the late Renaissance
and the early Baroque, many of the architects
and master builders on the most important
Roman construction projects came from

northern Italy, from Lombardy and from Ticino. In the "Eternal City" Caravaggio would have encountered an entire community of artists and builders from the north.

Nevertheless, his early years in Rome were anything but easy. The grand palaces being closed to him, he lived in cheap lodgings and prowled the narrow lanes of the lower city, living amid both the remains of ancient greatness and the beginnings of future magnificence. He often had to be satisfied with a simple salad for his meals. Irascible by nature, he got into trouble with the police; he spent time in hospital with a case of malaria, and bad nutrition and inadequate hygiene also took their toll. Finally, the painter from the north, called by everyone just "Caravaggio," found work with an established painter, Giuseppe Cesari, known as the Cavalier d'Arpino.

Caravaggio had to paint flowers and fruit for his master's pictures, a modest start for his rise to fame. However, an important aspect of his art also became apparent at this point: Caravaggio clearly had a special feeling for the details of nature. Able to reproduce them very accurately, he gave them their own soul and a unique artistic dignity that, as purely ornamental accessories, they had not previously enjoyed. Within a few years, Caravaggio became one of the most important pioneers of a new art form, the still life, which challenged the traditional hierarchy of subjects in painting. He is credited with saying: "It costs me as much of an effort to paint a good flower piece as to paint a picture with figures in it."

Life on the streets

Caravaggio was still living on the edge of society, far from the formal magnificence of the papal capital and its ceremonies—and its major commissions. It also appears that the young painter paid scant regard to the overpowering wealth of ancient splendor to be found in Rome. Instead of the resplendent beauty of the marble statues of antiquity, which had been a key inspiration during Renaissance, he preferred to absorb the color and drama of daily life on the streets, which he took great pains to depict faithfully in his paintings. This is the revolutionary change that Caravaggio's painting brought to art. And with it the Renaissance ended.

Almost without exception, Caravaggio's first pictures show scenes from ordinary life, not from history, classical mythology, the Bible, or the lives of saints. Typically, a few figures appear in front of a light-toned background, the clear light of day falling diagonally across a colorful scene. A gypsy woman tells the fortune of a well-dressed youth by reading his palm (*The Fortune Teller*)—and, without the rather careless young man noticing, she slips a ring off his finger. Two streetwise cardsharps dupe an unsuspecting youth from a well-to-do family (*The Cardsharps*). Four street boys prepare for an improvised concert, a scene whose meaning could be both deeply allegorical as well as ambiguously erotic (*The Concert*). Equally sensual and ambiguous, a young man with curly dark hair appears to offer the observer an abundantly filled basket of fruit (*Boy with a Basket of Fruit*), and a rather plump youth wearing the robes

of the god Bacchus, his head crowned with vines, raises a glass goblet full of red wine (*Bacchus*).

Caravaggio's first patron: Cardinal del Monte

It was with such vivid and often ambiguous images that Caravaggio slowly became known in Roman art circles. Eventually, the influential Cardinal Francesco Maria del Monte became aware of the young artist from Lombardy. Taking a liking to Caravaggio's paintings, Del Monte purchased several; he also encouraged him to continue on his chosen artistic path and even offered to provide him with food and accommodation in his fine Roman residence. For Caravaggio, admission to the home of the Cardinal opened the doors both to the art collections of the Roman aristocracy and to wealthy patrons. The obscure painter from the north, with his unconventional subjects and vivid style, quickly became a topic of conversation for wealthy connoisseurs with unconventional tastes.

Caravaggio's works from this period are some of the most graceful compositions in his oeuvre. His *Rest on the Flight into Egypt*, one of the few Caravaggio pictures that has a landscape background, once again employs a Lombardian realism. A characteristic blending of the human and the divine is also seen in his *Penitent Magdalene*. According to a seventeenth-century writer, Giovanni Pietro Bellori, Caravaggio chose a simple girl from the street as his model for the figure of Mary Magdalene, and it is only the jewelry lying on the floor that identifies the young woman as the penitent sinner from the Gospels. The idea of using people from the streets as models for biblical figures was not new, as the Apostles in Leonardo's *Last Supper* show. However, in Leonardo's day, at the peak of the Renaissance, other considerations prevailed. Caravaggio's carefree handling of religious subjects shocked respectable people: What had happened to the dignity of art, where was the *decorum* (a Renaissance concept of what was fitting in art)?

But Cardinal del Monte, for one, was happy in the role of supporter of young talent and sent Caravaggio's *Still Life with a Basket of Fruit* to Federico Borromeo, the brother of Milan's Archbishop Carlo Borromeo, and thus ultimately the painting found its way to the Pinacoteca Ambrosiana in Milan.

The Matthew Cycle

Meanwhile, Caravaggio had developed new forms of expression for depicting terror and pain, surprise and ecstasy. The year 1600 marked a turning point in his work. Previously he had almost exclusively painted medium-sized paintings of secular subjects with only a few figures. Now he had the opportunity to try out new formats, subjects, and themes. One important commission was for an altarpiece with two side paintings for the funeral chapel of Cardinal Mathieu Cointrel (Matteo Contarelli in Italian) in San Luigi dei Francesi, the national church of France in Rome. The subject was St. Matthew. The work had been intermittent for years; several artists had tried but failed. Caravaggio also encountered difficulties at the start. The first version of the

altarpiece, *The Inspiration of St. Matthew*, which shows the saint writing the Gospels, was rejected because of its crude realism. The second, successful, version concentrated on the exchange of gestures and looks between the evangelist and the heavenly messenger who swings down into the scene from above. However, the most innovative and unusual works are presented by Caravaggio on the side walls of the chapel. They were so innovative that they can be considered a turning point not only in his own work, but also in European painting.

The picture on the left of the altar is *The Calling of St. Matthew*. The saint sits at a heavy table between sentries on one side and tax collectors on the other; the background is simply a whitewashed wall with a small dusty window. A beam of light falls diagonally across the scene from the right: it illuminates the plumes of the soldiers dressed in seventeenth-century uniform, and shines on the hands of the tax collectors greedily counting their money. Christ also enters the scene from the right, half hidden by the figure of St. Peter. One look—that is all it takes. With the same imperious gesture as that of God the Father giving life to Adam in Michelangelo's ceiling paintings in the Sistine Chapel, Christ calls the new disciple to follow him. With a gesture reminiscent of that of one of the Apostles in Leonardo's *Last Supper*, Matthew points to himself and appears both questioning and surprised. All this takes place in a brief moment yet still has the power of an immediate and eternal truth. Although Caravaggio's paintings are some of the most

Boy Bitten by a Lizard (detail), 1595–1596, Fondazione Longhi, Florence

17

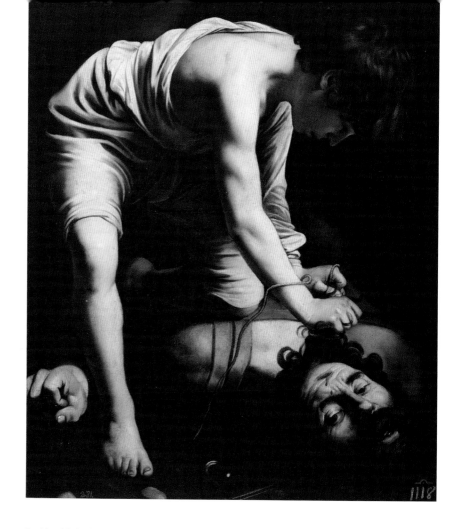

David and Goliath,
c. 1597–1598, Museo
Nacional del Prado,
Madrid

famous pictures in the history of art, the moment of calling appears new to our eyes each time we see it, as if the scene were happening in the very moment of our seeing.

While *The Calling of St. Matthew* is a picture in which an event unfolds quietly before the eyes of the observer, *The Martyrdom of St. Matthew* (on the right of the altar) shows a sudden outbreak of violence and terror. The murderer has mercilessly pulled the aged priest from the altar and with a scream has stabbed him. The victim lies on the ground and gives a loud groan, an altar boy runs away screaming, the faithful recoil in horror. Darkness spreads around the figure of the fallen Apostle. A single angel reaches down from above and offers him a palm branch as a sign of his glorious martyrdom. It is not clear, however, whether the old man on the floor is lifting his arm to take the palm of martyrdom or to protect himself from his murderer. On the left in the background a man aged around thirty with a dark beard and arched brows turns his head to face the scene. This is Caravaggio himself, shown as an eye-witness to the crime, which is not in the past but in the ever present moment.

From this point on, Caravaggio rarely painted the colorful genre scenes of the kind that had made his name in Rome; he now devoted himself exclusively to religious subjects. His Roman altar paintings brought a deeply human perspective to the drama of martyrdom and spiritual election. Matthew, Andrew, Peter—Caravaggio's saints are defenseless old men who appear to plead for a little succor and mercy in the face of the cruel death they are facing. Of course, Caravaggio's works are full of the repertoire of stock figures encountered in the art of the Counter Reformation: sweet-looking angels, heroic witnesses of faith, pious virgins, and humble believers. But he shows them with greater realism and humanity. His images give the impression of the Here and Now. With each work his inner involvement increases, his personal fate permeating his works more and more. This can be seen through a comparison of the two versions of *Supper at Emmaus*, which reflect two very different moments in Caravaggio's spiritual and artistic development.

Other works for Roman churches

Caravaggio had made not only friends among the artists and collectors of Rome; he had also made enemies in all walks of life, and occasionally found himself in the law courts. However, despite concerns about his life and his art, the Matthew Cycle for San Luigi dei Francesi became celebrated in Rome's art circles, and he received a number of important commissions for altarpieces in Roman churches. For the Loreto Chapel of the church of Sant'Agostino, which was often visited by simple believers, Caravaggio created his famous *Madonna of the Pilgrims*. In accordance with the works intended purpose, he gave the Madonna a touching and simple expression: an ordinary woman with black hair, she stands with the Infant Jesus in her arms on the threshold of a plain house. In front of her kneel a barefoot old couple who appear much too emotional to fully comprehend the wonder of the event occurring before their eyes. The

sharply focused light draws attention to their poor clothes and unwashed feet, yet without diminishing their dignity.

Caravaggio's simple human truth was in marked contrast to the aristocratic classicism of the Bolognese artist Annibale Carraci, who drew on the history of art from antiquity to the Renaissance in his paintings. A good ten years older than Caravaggio, Carraci had come to Rome in 1590, just a few years before the younger man. Unlike Caravaggio, however, he enjoyed great success from the start, his refined and elegant style being widely admired. He soon received one of the most prestigious commissions that a painter in Rome at that time could ever wish for: to paint the magnificent Galleria of the Palazzo Farnese for Cardinal Odoardo Farnese.

It was Cardinal Tiberio Cerasi who commissioned the two artistic opposites to decorate his family chapel in the church of Santa Maria del Popolo. In the contract, Caravaggio, who was not yet thirty, is described as "egregius in urbe pictor" ("the outstanding painter in the city"), which clearly shows that his reputation, despite all his personal and professional scandals, was now well established. Carracci was responsible for the altarpiece showing the Assumption of Mary, Caravaggio for two side scenes depicting the Conversion of St. Paul and the Martyrdom of St. Peter. And here again he broke with tradition: no explanatory accessories, no jubilant angels, no obvious allegorical or moralistic symbolism, just naked reality—all-too-human dramas in which spiritual depth is hidden in the scene's tangible immediacy.

Caravaggio also depicted this type of drama in *The Entombment of Christ* for the church of Santa Maria in Vallicella, in which numerous artists of the period had been employed. In his *Entombment*, the figures are huddled together in a staged display of agony that is reminiscent of the art of Michelangelo. The position of the thick grave slab, which appears to jut out of the picture plane into the viewer's space, is striking. Peter Paul Rubens copied the work, though significantly he did not include the dramatic gestures.

Caravaggio's success continuing, he next received a commission from the Vatican, or, to be more precise, from the Archconfraternity of the Papal Grooms, who commissioned a painting for St. Peter's Basilica. But what could have been the chance of a lifetime ended as a fiasco. The intended setting seemed to require a triumphal and ceremonious tone. Caravaggio, however, instinctively chose a bold, realistic depiction of the holy figures in front of a sparse, dark background. Blind to the subtle beauty of the painting, the *Madonna dei Palafrenieri*, the Archconfraternity rejected it, considering the depiction of Jesus as a naked child to be as scandalous as the depiction of St. Anne as a woman whose age is all too apparent. The painting was on display in St. Peter's for only a few days and was then moved to the church of Sant'Anna dei Palafrenieri (hence its title); it was later purchased by Cardinal Scipione Borghese, who was a keen collector of Caravaggio's works, as demonstrated by the large number of paintings by the artists that are now in the Galleria Borghese in Rome.

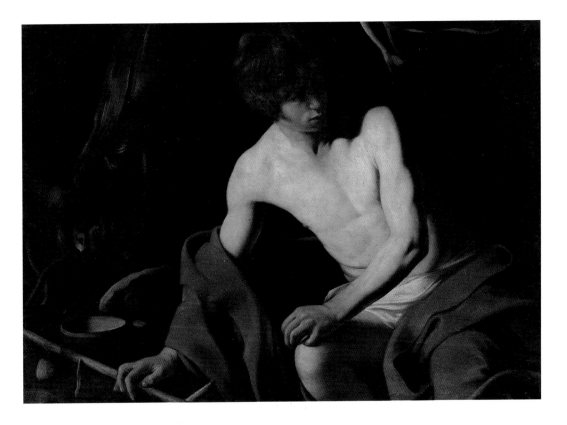

1606: a fateful year

Despite such controversies—or perhaps be-
cause of them—Caravaggio had also become
a sought-after painter outside of Rome. A re-
quest from Prince Marcantonio Doria was
sent from Genoa, which was experiencing
a period of new architectural and artistic
growth at this time. He offered the artist the
grand sum of 6,000 ducats to paint the loggia
of his villa in Sampierdarena. But Caravaggio,
who had no experience of painting in fresco,
rejected the offer. (Several years later, Doria
was able to console himself by purchasing
The Martyrdom of St. Ursula, one of the mas-
terpieces from Caravaggio's later phase, for
the family collection.) However, the events of

1606 were to introduce an abrupt change in
the life and works of Caravaggio. He was now
thirty-five years old and at the height of his
fame. Artists from across Europe came to
Rome to study and copy his work. These *Car-
avaggisti* painted everyday and religious
scenes in the manner of their inspiration,
eagerly copying his earthy realism and his
dramatic chiaroscuro.

In 1601 Caravaggio had received a com-
mission for an altarpiece for the Carmelite
church of Santa Maria della Scala in Traste-
vere. The painting, *The Death of the Virgin*,
which was completed only in late 1605/early
1606, is one of Caravaggio's greatest works,
even though it dealt with a traditional subject

*St. John the Baptist,
c. 1603–1604, Galleria
Corsini, Rome*

in a highly unconventional way. It depicts the Apostles and Mary Magdalene at the deathbed of the Virgin Mary; simple people, united in grief in a plain, almost bare, setting. The body of the Virgin is given prominence by the striking visual link between the red of her dress and the matching blood-red of the curtain hung above her.

The picture caused a scandal. Many people resented this portrayal of the dying Mother of God—the way she lies there chalk-white, bloated, her bare feet stretched out over the edge of the deathbed. Even worse, the painter, so the rumors claimed, had used the body of a prostitute who had drowned in the Tiber as the model for the figure of the Holy Virgin;

The Incredulity of St. Thomas, 1600–1601, Sanssouci, Bildergalerie, Potsdam

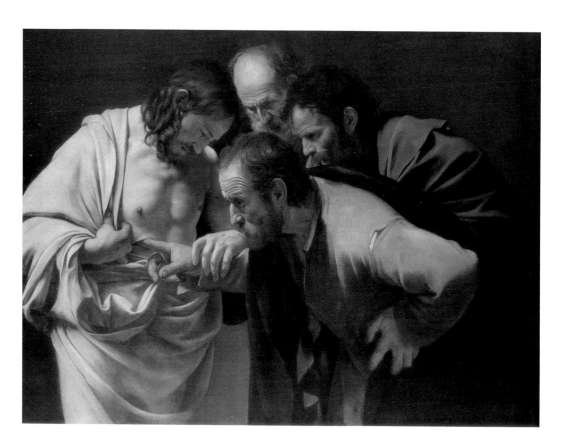

known as Lena Antognetti, she had been Caravaggio's model when alive and, allegedly, also his lover. The Carmelites indignantly refused to display the scandalous picture in their church. On the advice of Peter Paul Rubens, however, it was purchased by Vincenzo Gonzaga, the Duke of Mantua, for his collection; from there it came into the possession of Charles I of England before finally entering the Louvre.

In 1606, the scandal of Caravaggio's *The Death of the Virgin* was not the only shadow to fall over the life of the artist, who by now was famous far from Rome. During the evening of 28 May, a fateful quarrel took place in the Campus Martius in Rome. The cause was a wager on the outcome of a game of tennis. A disagreement led to a scuffle between Caravaggio's companions and several other men. Caravaggio was injured; one of his assailants, however, a man called Ranuccio Tommasoni, was killed by Caravaggio. News spread like wildfire. Hunted by the authorities, Caravaggio fled from Rome with the help of Prince Marzio Colonna; he was later sentenced to death *in absentia*. Caravaggio, who so often painted executions, was now in danger himself of dying under the executioner's blade.

After a short stay at the residences of the prince in Zagarolo and Palestrina, where he recovered from his injuries, Caravaggio moved to Naples. Thus began a four-year odyssey that took the artist, who could not return to Rome, where certain death awaited, to Malta, Sicily, and back to Naples, while his high-ranking friends tried to obtain a pardon. Caravaggio became a fugitive.

Naples: a new start

Like Caravaggio's hometown of Milan, Naples also belonged to the Spanish crown. At the beginning of the seventeenth century, which saw the emergence of the Baroque, architecture and art were flourishing in Naples, which was one of the most densely populated cities of Europe. Caravaggio's visit, though brief, was to make its own lasting impression on Neapolitan painting.

In a contract dated 6 October 1606, the Dalmatian businessman Nicola Radulovic detailed an advance made to Caravaggio for a painting described as follows: "At the top, the picture of the Madonna with the boy Jesus on her arm, surrounded by choirs of angels, with St. Dominic and St. Francis below in the center in a fraternal embrace; to the right there is St. Nicholas, and on the left, St. Vitus." This description does not exactly match Caravaggio's *The Madonna of the Rosary*, which today hangs in the Kunsthistorischen Museum in Vienna, and it is unclear whether this Viennese painting is in fact the one commissioned by Radulovic. The Viennese picture was later trimmed so that it could be hung in the Rosenkranzkapelle of the Dominican Church in Antwerp, as a bequest from Louis Finson, a Flemish painter who bought the painting during a visit to Naples.

Today only a few of Caravaggio's works are still in the places for which they were painted. One of these is the painting *The Seven Works of Mercy* in the chapel of the church of Pio Monte Palazzo della Misericordia, a thematically complex and dynamic work that is crowded with figures. Caravaggio brilliantly

unites the Christian Works of Mercy in a single picture. At first glance, the scene appears to be a snapshot of the turbulent life in the dark lanes of the Spanish Quarter of Naples. From an elevated position, the Madonna observes events over the shoulders of two angels falling headlong into the scene. In part, the sense of movement in the composition, which is quintessentially Baroque in its dynamism, stems from the fact that the picture does not have a central vanishing point. The preserved contract shows that Caravaggio received the sum of 470 ducats for the painting, which was a huge sum at the time. In addition, the Building Committee of Pio Monte Palazzo della Misericordia specified in 1613 that the painting should never be sold or moved from its location in the chapel.

Meanwhile in Rome, Rubens recommended that the Gonzagas purchase Caravaggio's *The Death of the Virgin*. Due to the forced sale of the assets of Caravaggio's former employer, the Cavalier d'Arpino, Cardinal Scipione Borghese purchased the *Boy with a Basket of Fruit* and the *Bacchus*. Finally, Caravaggio received the sum of 440 ducats in two payments on 11 and 29 May from Tommaso de' Franchis for *The Flagellation of Christ*, which the buyer donated to the church of San Domenico Maggiore in Naples. This work includes elements from Titian's *The Crowning with Thorns*, which Caravaggio had seen in his youth. In both paintings Christ is surrounded by the executioner's assistants, who play a brutal game with the condemned man. In Caravaggio's version, the athletic body of the Redeemer stands out against the darkness behind him,

in which stands the column to which he is bound .

Malta: from knight to prisoner

By the summer of 1608, Caravaggio could no longer bear to live in Naples. He started out on the next stage of his long journey south and took the boat to Malta. Since 1530, the island kingdom of Malta had been the home of the Knights of the Order of St. John (from then commonly known as the Knights of Malta), who gradually had to withdraw from the Holy Land and the Eastern Mediterranean region. Often the sons of noble families from across Europe, the Knights of Malta were mainly deployed at sea in the battle against Barbary Corsairs and the Saracens. The Order had turned the island into a fortress. Valletta, the capital city and seat of the Grand Master, where the richly decorated church of San Giovanni served as the burial church of the Order, possessed a unique character that combined elaborate medieval defenses and Baroque opulence.

Caravaggio quickly felt at home in this new world. He was welcomed as an honored guest and soon commissioned to painted portraits of several knights of the Order, including Fra Antonio Martelli and Grand Master Alof de Wignacourt in full armor. On 14 July 1608, Caravaggio was officially accepted into the Order of St. John. His first religious commission for the Knights was a St. Jerome for the church of San Giovanni. This in turn led to Caravaggio's great painting *The Beheading of St. John the Baptist*, which was intended for a side chapel in the church; it is the only paint-

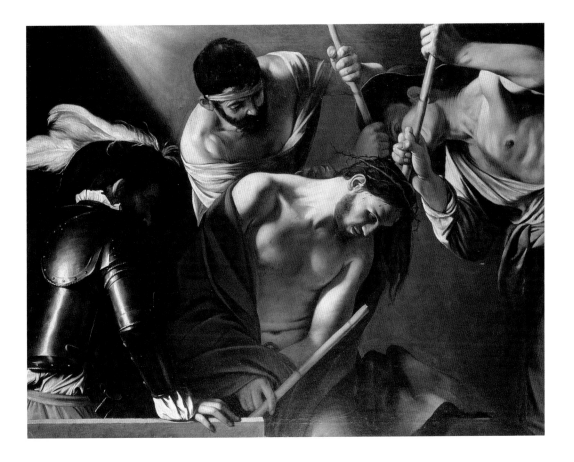

ing he signed. With this painting, Caravaggio's art reached a new—and final—level of expression. The vivid colors and fine details of his early years have disappeared. The focus is now on space and its role in the drama of his scenes.

In *The Beheading of St. John the Baptist*, the main figures are grouped together on the left of the picture, while on the right there is only the emptiness of a prison yard. John the Baptist lies beheaded on the ground, the executioner bending over him to cut the head from the body with the knife he is drawing from his belt. The jailer points to the golden dish that

a servant girl holds to take the head of the Baptist to Salome, who had demanded it as the price for her dance before King Herod. Horrified, an old woman hides her face in her hands. On the right, two prisoners watch the execution through the bars of their cell. A scene of cold and remorseless violence, it must have reminded Caravaggio of the death sentence that still hung over his head like the sword of Damocles. Maybe this is the reason why it is the only work of his oeuvre that he signed: "f. Michelango" (Fra Michelangelo) in the blood of the martyr, using his title as a Knight of St. John.

The Crowning with Thorns, c. 1603, Kunsthistorisches Museum, Vienna

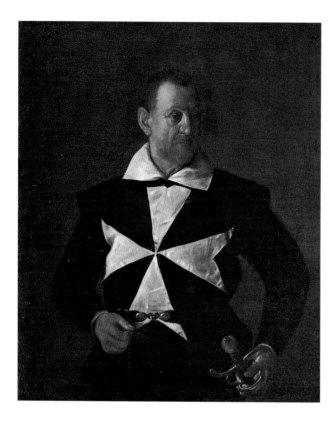

*Portrait Fra Marcanto-
nio Martelli, c. 1608,
Galleria Palatina,
Florence*

For Caravaggio, on the run from the law, the situation became critical again when news of the Roman judgment against him reached Valletta. "Fra Michelangelo," whose rapaciousness and disrespect to superiors and brothers had already left a bad impression in Malta, was expelled from the Order and imprisoned. Familiar with prisons by this time, he managed to escape and took the boat to Sicily.

His complete fall from favor is indicated not only by the formal *Damnatio Memoriae*—the document expelling him from the Order and expunging him "from its memory"—but also by the fact that his celebrated portrait of Alof de Wignacourt, of whom he may have painted several portraits, and who at that time was one of his most important patrons, was not included in the items Wignacourt bequeathed to the Order.

Sicily: a brief respite

In Sicily, Caravaggio traveled first to Syracuse, then to Messina and Palermo. The pictures he painted during this period are even more dramatic, the space in which the figures are placed emptier and more oppressive. In Syracuse, Caravaggio spent a carefree period with his painter friend Mario Minniti, who was accused of bigamy, and who possibly had helped him to escape from the dungeons of the Knights of Malta. Amid the ancient Greek ruins of the city, Caravaggio, who had never shown any interest in the ancient world when he was in Rome, suddenly discovered a passion for antiquity. It is said that during a walk through Greek Syracuse he coined the name

the "Ear of Dionysius" for one of the artificial grottos created in an ancient quarry.

The little church of Santa Lucia, for which Caravaggio painted the altarpiece *The Burial of St. Lucy*, is located some way outside of the city, just by her grave. The lifeless body of the young saint lies close to the lower edge of the picture, while above the group of mourners towers an immense empty space as heavy as fate itself; there is only one bright accent—the red of a garment—amid the almost monochrome gloom of the scene.

In December, and still masquerading as a Knight of Malta, Caravaggio traveled to Messina, where he received commissions for several large altarpieces. One was *The Raising of Lazarus*, which the Genoese businessman Giovan Battista Lazzari donated to the church of the Padri Crociferi. Caravaggio allegedly asked for a cadaver from the hospital to use as a model—a request that shocked his hired assistants, who had to hold the corpse in position. After *The Raising of Lazarus*, which was finished on 10 June 1608, he immediately started work on a commission from the Messina city council for the local Capuchin church. For the *Adoration of the Shepherds*, Caravaggio received the dizzying sum of 1,000 ducats. But there was more: the Messinian collector Niccolò Giacomo asked Caravaggio to paint four pictures with subjects "according to the painter's ideas," adding that he was to be paid "as much as is fitting for this painter with a crazy mind." According to Giacomo's records, one of these works, a depiction of Jesus carrying the Cross, was at that time

almost complete and the remaining three were to be completed by August.

However, Caravaggio was soon to leave Messina, spending the months of August and September in Palermo. There he created the elegant *The Adoration of the Shepherds with St. Lawrence and St. Francis*, which hung in San Lorenzo in Palermo until it was stolen in 1969.

Naples again: Caravaggio's final works

On 20 October Caravaggio returned to Naples. A few days later, on 24 October, he was involved in a brawl in a tavern during which his face was injured. His fellow painter Giovanni Baglione, one of the first but also one of the most embittered biographers of Caravaggio, claims that Caravaggio had to leave Sicily to escape from the Maltese authorities, and that he received such serious injuries in the fight that he could hardly be recognized.

Very few archive documents remain from Caravaggio's second stay in Naples. In some cases, the chronological sequence of works created during these months is disputed; this is the case, for example, with *Salome with the Head of John the Baptist* (National Gallery, London) and the *Toothpuller* (Palazzo Pitti, Florence), which is in poor condition. Three paintings from the Cappella Fenaroli—a St. John, a St. Francis, and a Resurrection of Christ—have been completely lost, destroyed when part of the church of Sant'Anna dei Lombardi in Naples collapsed during an earthquake in 1798. An unusual interpretation of the theme, the Resurrection showed Christ

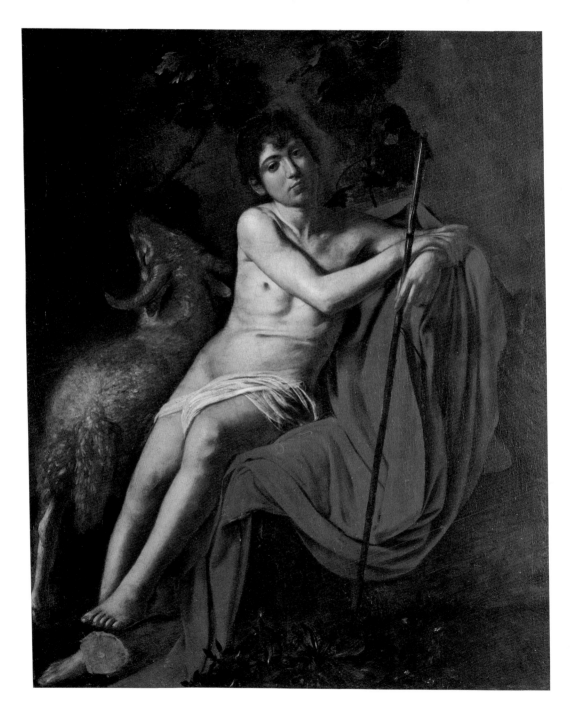

climbing silently out of the grave past sleeping guards. Caravaggio's last work painted in Naples was probably *The Martyrdom of St. Ursula*, for the collection of the Prince of Genoa, Marcantonio Doria. And it was in Naples, in a painting likely created in the last months of his life, that Caravaggio gave one of his figures the features of his own face. It is that of the defeated giant Goliath, whose head has been severed from his neck by the youth David. The gaping wound on the brow of the Philistine could be the same as that received by the painter during his second stay in Naples. The expression of the defeated man reveals bitter abandonment. Curiously, and perhaps uniquely, the young victor appears to feel a melancholy sympathy for the giant who became a victim at his hands.

While Caravaggio worked in Naples on powerful works such as these, he still hoped for a pardon so he could return to Rome. In the end it was Cardinal Ferdinando Gonzaga who interceded on his behalf and obtained the long-awaited pardon from the papal court.

An end to running

By July 1610 a pardon was imminent. However, for legal reasons Caravaggio was not able to take the overland route back to Rome.

He had to travel to the Papal States via a port in the south of Tuscany, Porto Ercole, which was under Spanish rule. But when he briefly disembarked at Palo, a tiny garrison port just before Porto Ercole, he was arrested. The killer and ruffian who until recently had been on the run from the law, and who was still under the threat of a death sentence, was thrown into prison. Ironically, it was a case of mistaken identity. But by the time he had managed to prove his identity, the ship had already sailed. All his possessions were on board. He then suffered an attack of malaria, the illness that had haunted him since his youth. On 18 July 1610 he was alone on the shore of the Tyrrhenian Sea. He died, as Giovanni Baglione wrote, "without the aid of God or man." As soon as news spread, the Knights of Malta claimed his goods, insisting that he was still a member of the Order. The authorities in Naples got involved, in the form of the Spanish Viceroy, Don Pedro Fernández de Castro, and Caravaggio's possessions were seized. A few paintings went missing. It was some time before the remainder reached Cardinal Borghese in Rome.

Caravaggio was only thirty-nine years old when he died, but his art had already started to transform European painting.

Opposite page:
St. John the Baptist,
1609–1610, Galleria
Borghese, Rome

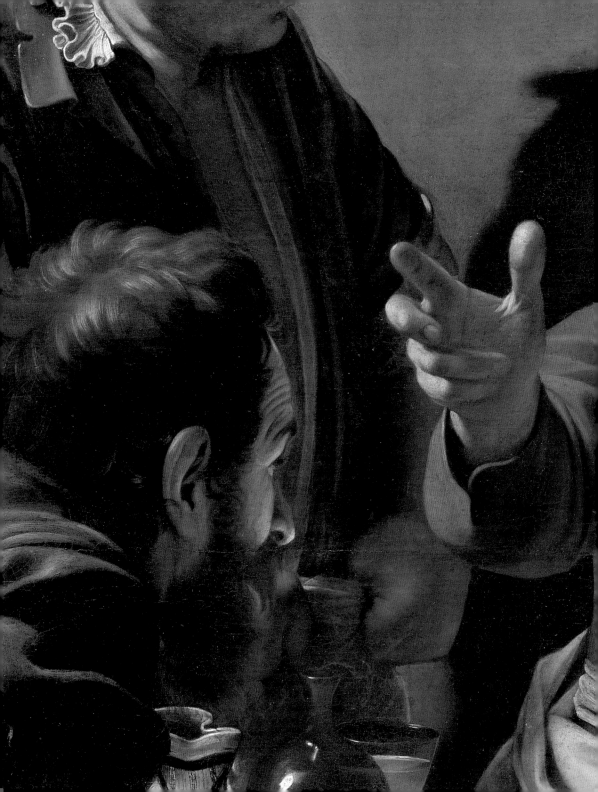

WORKS

Sick Bacchus

1593–1594

*Oil on canvas, 67 x 53 cm
Galleria Borghese, Rome*

This unusual image of the god of wine as young and sickly was originally owned by the Cavalier d'Arpino, a late Mannerist painter for whom Caravaggio worked during his first stay in Rome. In 1607, when the Cavalier's assets were confiscated by the tax authorities, the painting was sold to Cardinal Scipione Borghese, which explains why today it is in the collection of the Galleria Borghese.

As no paintings from Caravaggio's time in Milan are known to have survived, this Bacchus counts as one of his earliest surviving works. Because of the unhealthy color of his face, many see the figure of Bacchus as a self-portrait by Caravaggio when he was in hospital with a fever. As his early biographer Giovanni Baglione reported, at that time Caravaggio painted "several small pictures in front of the mirror and the first of these was a Bacchus with various types of grapes. These were painted with great care, albeit in a dry manner." Caravaggio's Bacchus does not have the usual crown of vines; instead, as a sign of ever-lasting youth, he is crowned with ivy. The pale skin, the thin almost gaunt body, and the strange withdrawn stance also differentiate him from other portrayals of the voluptuous god of wine. The Caravaggio authority Mina Gregori has pointed out that the silvery color of the face, the twisted body position, and the ancient belted garment worn by the young god reflect the influence of Caravaggio's teacher in Milan, Simone Peterzano.

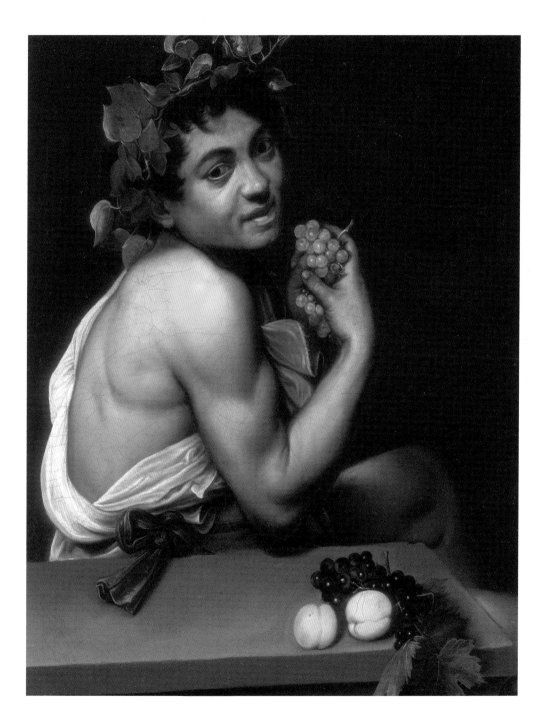

Boy with a Basket of Fruit

1593–1594

Oil on canvas, 70 x 67 cm
Galleria Borghese, Rome

The naturalism expressed in Caravaggio's early Roman pictures is demonstrated with parti-
cular clarity by his very precise depictions of the objects of everyday life. Many of his works
from this period show blossoming fruit, flowers, and boys. However, there are also hints of
decay and the transiency of beauty, such as the beam of light that illuminates the room
behind the boy, a reminder of the fleetingness of the moment. And among the fruits and
leaves in the generously filled basket that the young man appears to offer the viewer,
objects painted with an almost photographic brilliance, some leaves have already wilted.
The similarities between this painting and his *Still Life with a Basket of Fruit*, one of the very
early examples of the genre of independent still life that was just emerging at the beginning
of the seventeenth century, are obvious. However, the picture of the boy unmistakably belongs
to Caravaggio's early works, which feature the ordinary people of Rome. Genre scenes
depicting figures with generously presented arrangements of fruit and flowers were very
popular with royal collectors of the early seventeenth century; painters such as Peter Paul
Rubens and Jacob Jordaens also included the subject in their repertoire.
Like other early works by Caravaggio, his *Boy with a Basket of Fruit* entered the collection of
Cardinal Borghese when the assets of the Cavalier d'Arpino were confiscated by the papal
tax authorities.

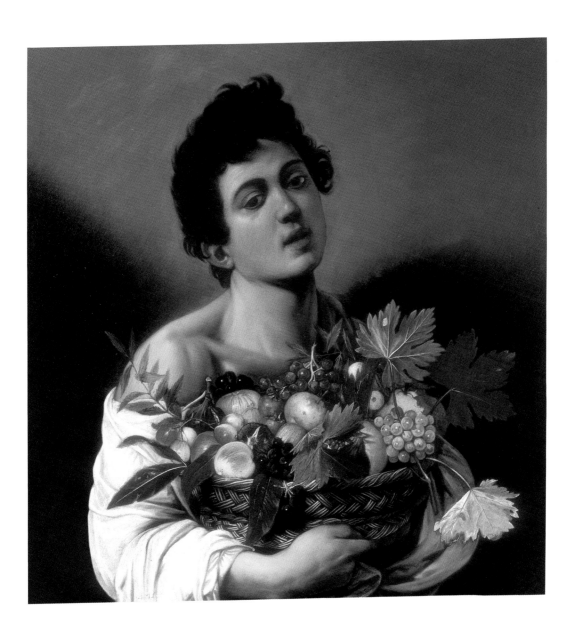

The Fortune Teller

1593–1594

Oil on canvas, 115 x 150 cm
Musei Capitolini, Rome

This early work clearly shows Caravaggio's artistic indebtedness to the Lombardy School of the sixteenth century. It depicts an event from daily life: besotted with the charms of an elegantly dressed young gypsy woman, a callow youth wearing a fine doublet, feathered hat, and sword lets the smiling fortune teller read his palm without noticing that she has stolen the ring from his finger.

This painting, with its clear moral reminder not to be tricked by attractive seeming deceptions, quickly became popular and was often copied. In his observations about the painting, the seventeenth-century writer Giulio Mancini acknowledged that the picture had "much grace and feeling," though in principle he rejected such scenes from everyday life, which were without a dignified subject from history or religion.

As a detailed examination of the painting has shown, Caravaggio used a canvas that had already been painted in parts. Unsurprisingly for a painter at the start of his career, it also showed traces of numerous corrections made during its execution. Caravaggio did not rely on preparatory studies here. Instead, he painted directly on to the canvas and drew only a few rough compositional lines with the handle of his brush.

The picture was painted as a commission from a Monsignor Petrignani, with whom Caravaggio was living at the time, and was later purchased by Cardinal Francesco Maria del Monte. A second version of the painting, which he created several years later, can today be found in the Louvre.

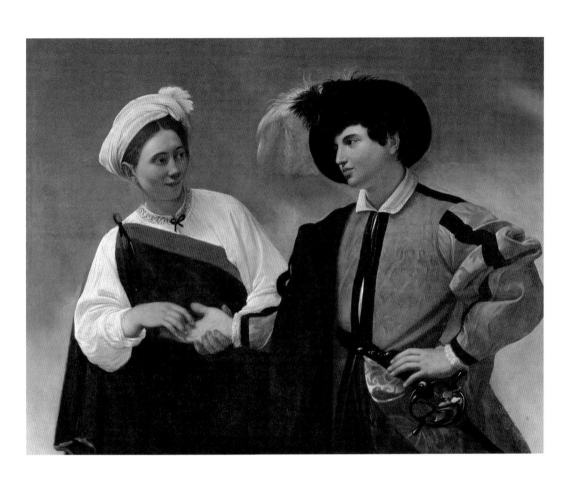

The Cardsharps

c. 1594

*Oil on canvas, 94.2 x 130.9 cm
Kimbell Art Museum, Fort Worth*

For a long time this picture, which was purchased from Caravaggio by Cardinal Francesco Maria Del Monte in 1597, was known only through copies. The subject was extraordinarily popular with copyists, Caravaggio's followers (*Caravaggisti*), and art collectors across Europe, and numerous replicas were in circulation. It was this situation that made the identification of the painting as an authentic work by Caravaggio so difficult.

Here Caravaggio combines subjects from the art of his north Italian hometown with a closely observed realism. The structure is typical of his early works: each figure is carefully posed and skillfully placed in the intricately structured and sharply illuminated composition, creating the impression of a tableau vivant. The figure at the back signaling to his partner, who is drawing a hidden card from his belt, and the dupe on the left, whose expression is one of guileless innocence, make it clear what game is being played here. Vividly recorded details, such as the holes in the glove of the figure in the middle and the pink feather worn by the figure on the right, create a vivid impression of reality. The correct perspective of the games board with dice and cup demonstrates Caravaggio's mastery as a still-life painter.

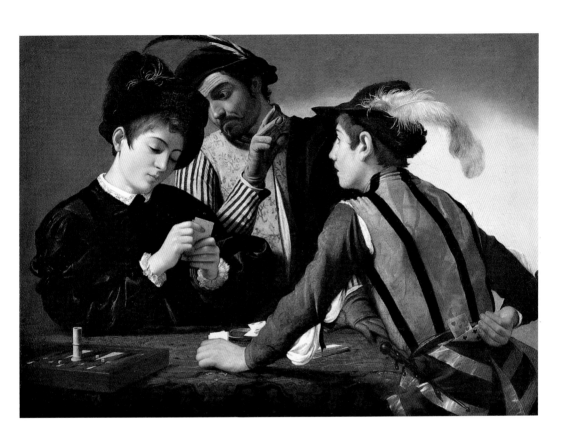

The Penitent Magdalene

1594–1595

Oil on canvas, 122.5 x 98.5 cm
Galleria Doria Pamphilj, Rome

In the eyes of Giovanni Pietro Bellori, a contemporary artist and biographer who rejected Caravaggio's realism in favor of traditional classicism, this painting was proof of the painter's tendency to portray "common people without grace or dignity." Bellori describes it with the following words in his *Lives of the Artists*, which was published in 1672: "A young girl in her room on a chair, her hands resting on her lap while her hair dries. However, by adding an ointment vessel and precious stones spread on the ground, he has turned her into a penitent Mary Magdalene." What Bellori saw as a weakness in fact defines the real attraction of the picture. Bellori's comment on the subsequent transformation of a secular theme into a biblical one has been shown to be true, for X-rays of the paintings have revealed that the attributes of the penitent sinner were added later.

Caravaggio created an atmosphere of great intimacy here from just a few elements. The slumped figure of the young woman in her heavy damask dress is emphasized. As the background remains almost in darkness, it is the geometric pattern of the monochrome floor tiles that gives the room an illusion of depth.

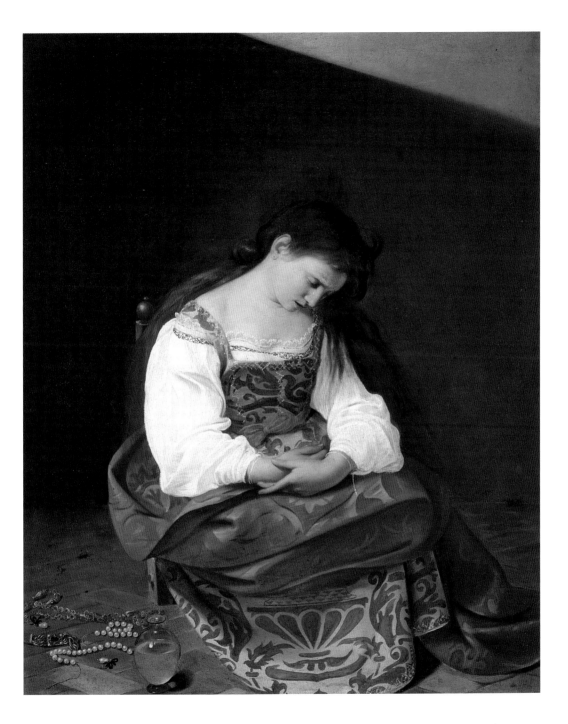

The Concert

c. 1595

Oil on canvas, 92.1 x 118.4 cm
The Metropolitan Museum of Art, New York

Most research suggests that this picture was the first work painted by Caravaggio after he moved to the Palazzo Madama, the residence of his new patron, Cardinal Francesco Maria Del Monte. The highly educated Del Monte was a keen music lover and he clearly inspired the young artist to paint several pictures featuring musical instruments or on musical themes.

Through the centuries, the surface of the painting has suffered considerable damage. This does not, however, diminish the ambiguous fascination of the image, which has given rise to the most diverse interpretations, including those that identify homosexual themes.

In all interpretations, it is the winged figure of the winged cupid in the background, who pulls a handful of grapes from a vine, that plays a key role.

The poor condition of the painting has raised doubts concerning its authenticity. A picture by Caravaggio with the same subject, that of *musica di alcuni giovani* (music played by young men), was mentioned by Giovanni Baglione in 1642. Numerous copies existed from an early date.

The young musicians dressed in old-fashioned robes are obviously still in rehearsal. They are tuning their instruments or studying the music, which gives the scene a special immediacy, as though they have been caught unposed. The lines of the lute's neck, which seems to jut out beyond the picture plane into our space, has the effect of drawing us into the scene and of beginning a circular movement from left to right that ends with the open page of the music book held be the boy with his back to us. The sense of space is also enhanced by the open book of music in the foreground, with its subtle shadows, and the bow protruding over the sound box of the violin, in effect a small still life.

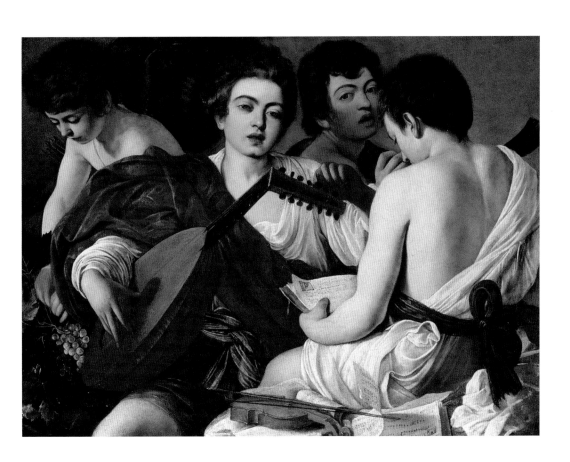

Boy Bitten by a Lizard

1595–1596

Oil on canvas, 65.8 x 52.3 cm
Fondazione Longhi, Florence

A lizard sits hidden within ripe, sweet fruits and bites the finger of the boy who has stretched out his hand to them. He flinches and his face contorts with pain and alarm. As with many pictures from his early period in Rome, Caravaggio painted this subject twice. In the matching work, which is in the National Gallery in London, the colors are brighter and clearer, while the paint application in this Florentine version is thicker and more opaque. The appeal of this scene lies in the vibrant contrast between the expression of sudden shock on the face of the boy and the detailed depiction of the objects set out before the viewer. Clearly modeled by a bright, clear light, the fruit, flowers, and water-filled glass vase, which clearly reflects the shape of a window, create the impression of a still life. A moral message is hidden in the confrontation between youth and the unexpected pain that at times lurks in the desirable goods of this world.

From a stylistic point of view, this early Roman picture also reflects Caravaggio's Lombardian origins. The efforts to portray human emotional reactions, by contrast, go back to Leonardo da Vinci, and also to Caravaggio's Milanese teacher, Simone Peterzano. More specifically, the expression of fright on the features of the boy is reminiscent of a drawing by the artist Sofonisba Anguissola from Cremona, which shows a boy pinched on the finger by a crayfish (c. 1557; *Asdrubale Bitten by a Crayfish*, Museo di Capodimonte, Naples).

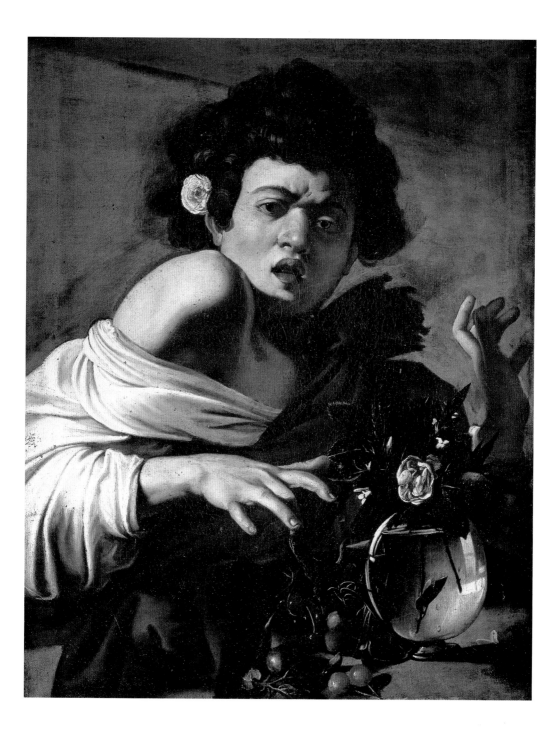

Rest on the Flight into Egypt

1595–1596

Oil on canvas, 135.5 x 166.5 cm
Galleria Doria Pamphilj, Rome

This enchanting small masterpiece is one of the few pictures by Caravaggio that includes the open countryside, the scene being bathed in the gentle light of evening. A winged angel plays the violin with his back to the viewer, while St. Joseph holds a book of music for him. With a white cloth draped over his youthful body and his naturalistic wings, Caravaggio's angel becomes a tangible earthly form. Similarly, the maternal gentleness of the Madonna, with her exhausted head resting on the small head of the Infant Jesus, appears deeply human.

In this painting, his first complex interpretation of a biblical subject, Caravaggio continues the forms, colors, and detailed realism of his secular paintings. The art historian Giulio Carlo Argan has noted that, by detaching himself from the influential style of Mannerism and from official Roman ecclesiastical art, Caravaggio made an artistic statement in favor of the realism nurtured in northern Italy. The gentle light, the landscape in the background, and the elegant figure of the heavenly musician create a rural idyll that is also reminiscent of Caravaggio's artistic roots in the north, in this case notable Venice.

The detailed figure of the young mother is based on a drawing by Caravaggio's employer at this time, the Cavalier d'Arpino, without, however, adopting his Mannerist tendencies.

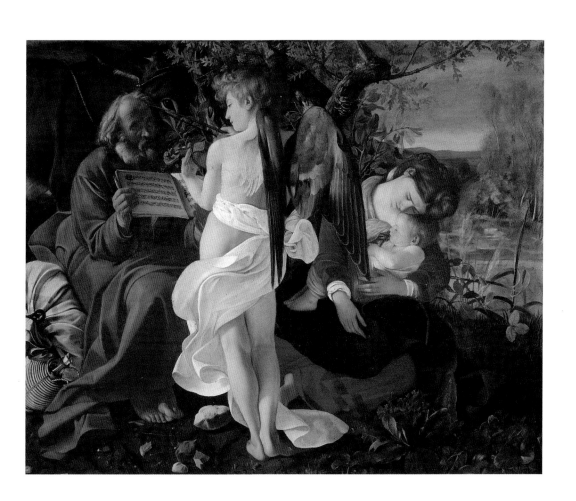

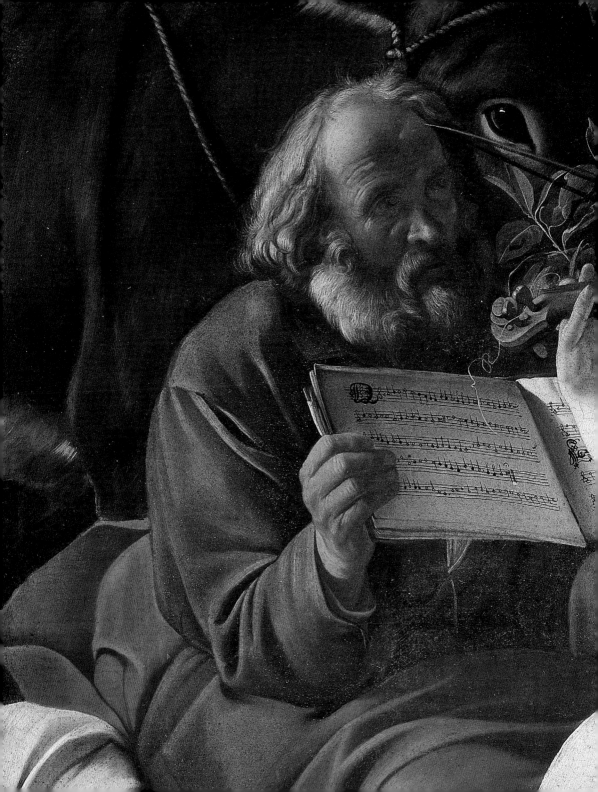

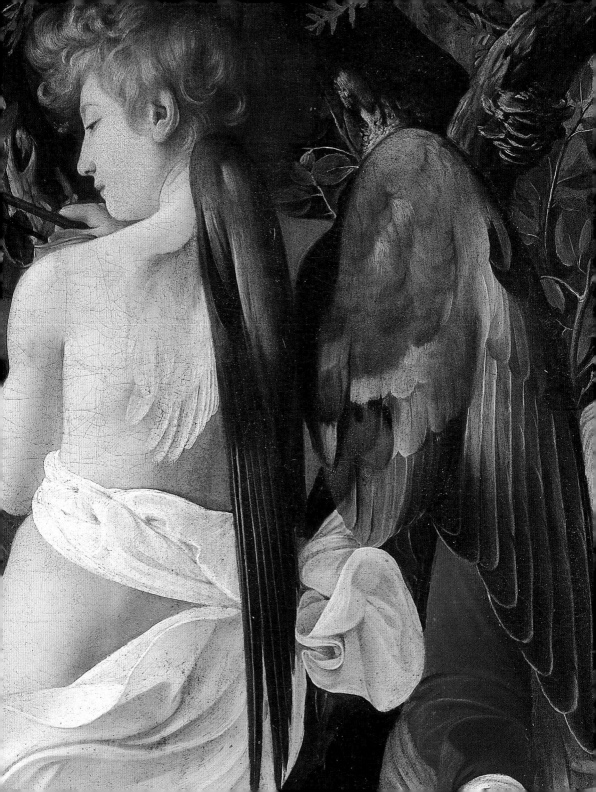

The Lute Player

1595–1596

Oil on canvas, 94 x 119 cm
State Hermitage Museum, St. Petersburg

As the numerous copies of Caravaggio's *The Lute Player* demonstrate, this subject was very popular with the noble Roman collectors of the early seventeenth century, and Caravaggio himself painted it several times. A number of paintings from his early Roman years feature musicians, musical instruments, and music scores, the inspiration for this almost certainly coming from his patron, the music lover Cardinal Francesco Maria Del Monte. Through him Caravaggio came into contact with composers of madrigals, and also poets from the circle of Giovan Battista Marino. As in other pictures of this type, the music notation and words in *The Lute Player* are easy to decipher. They are from the madrigal *Voi sapete ch'io v'amo* (You know that I love you), which was very popular in the sixteenth century.

Caravaggio is said to have used his painter friend Mario Minniti as the model for the half-figure boy shown turned slightly to the side as he plays the lute to accompany his own singing. Here again, Caravaggio links the human figure to elements of still-life painting; in this case, he uses flowers in a vase and some fruit, as well as the open book of music and a violin and bow, to give both verisimilitude and spatial depth to the image. The position of the viewer is assumed to be just a short distance from the scene depicted, a proximity emphasized by the dark background.

Caravaggio's versions for the Marchese Vincenzo Giustiniani (shown here) and for Cardinal Francesco Maria Del Monte (today in New York) refer to Lombardian models in the type of perspective portrayal of anatomical details, in particular to the works of Giovanni Girolamo Savoldo.

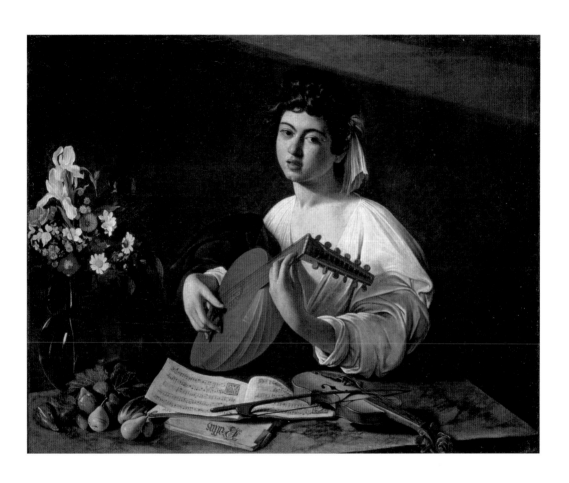

The Lute Player
(details)

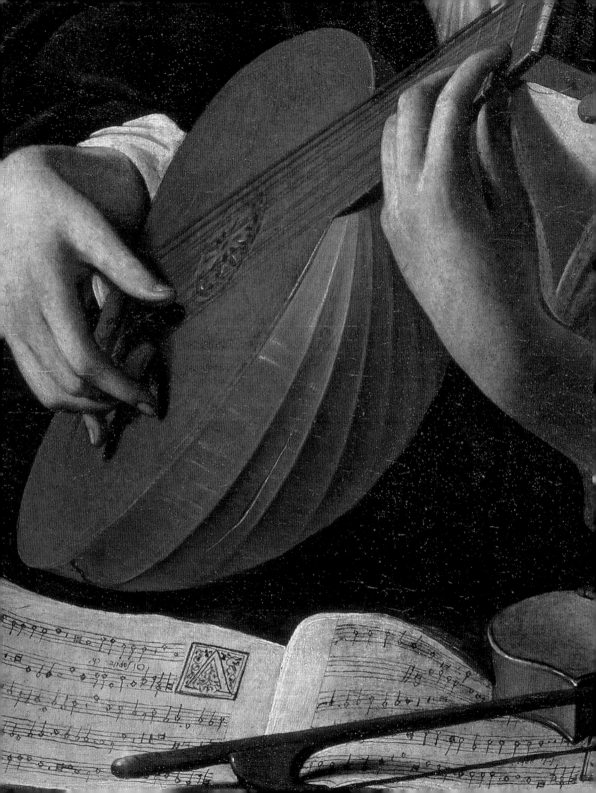

Bacchus

1596–1597

Oil on canvas, 95 x 85 cm
Galleria degli Uffizi, Florence

As in many of his Roman works, Caravaggio here displays his virtuosity as a painter of still-life details, notably the glass bottle and the arrangement of fruit (here in a ceramic dish, not in a basket as in similar works by Caravaggio). However, at the same time he also gives the figure of the young god of wine, whose eyelids and sensual month have become heavy through intoxication, an ambiguous expression. As in his *Sick Bacchus*, one can assume that Caravaggio used his own reflection as a model, as indicated by the fact that the figure holds the goblet in his left hand. The fullness and regularity of his face suggests the influence of portraits in Roman late-Mannerist style, in particular those by Scipione Pulzone. Caravaggio's *Bacchus* was discovered by Roberto Longhi and Matteo Marangoni in the store-rooms of the Uffizi at the beginning of the twentieth century. It was in a lamentable condition. Subsequent X-ray examinations have shown that the painter also made numerous changes and corrections. Working without preparatory drawings meant that the creative process was concentrated in the act of painting.

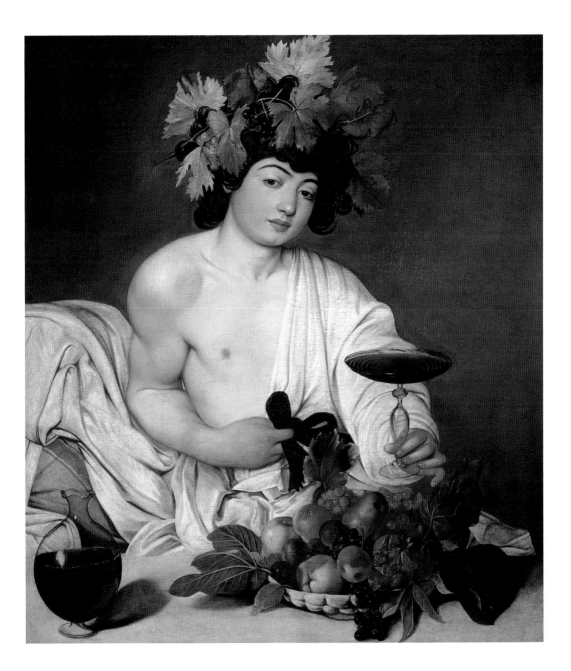

Medusa

c. 1597

Oil on canvas mounted on wood
Galleria degli Uffizi, Florence

Following a thorough restoration in 2004, this head of the Medusa, which was painted on canvas and later mounted on a panel of poplar wood, radiates a gruesome magnificence. As established in a note by Giovanni Baglione, Caravaggio created this round decorative panel to be used for parade armor as a commission from Cardinal Francesco Maria Del Monte in honor of his master, the Grand Duke of Tuscany, Ferdinand I de' Medici.

The image refers to the ancient myth of Perseus, which tells how the hero cut off the head of the monster, who had snakes for hair and who could turn to stone any mortal who looked at her, and then affixed it to his shield. The theme of decapitation returns many times in Caravaggio's oeuvre.

The open mouth of the Medusa, around whose head snakes swarm angrily, gives the subject a particular quality of pain and alarm that led the nineteenth-century Swiss art historian Jacob Burckhardt to observe that the same facial expression could also be seen when a tooth is extracted. Like all naturalists, Caravaggio, Burckhardt commented, was lacking the feeling for inner expression, which he sacrificed to the portrayal of the moment, so that he evokes "more revulsion than deep fear" in the viewer.

Caravaggio revisited the theme of a mouth opened in a silent scream in later works, for example with the figure of Isaac in *The Sacrifice of Isaac* and the altar boy in *The Martyrdom of St. Matthew.*

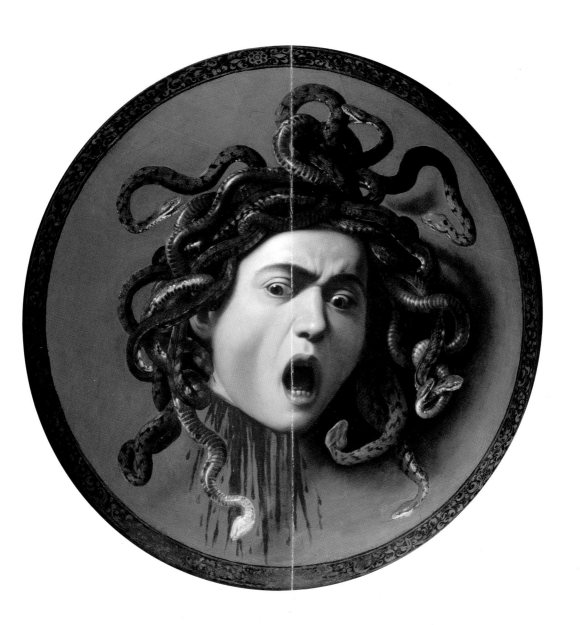

Still Life with a Basket of Fruit

1597–1598

Oil on canvas, 46 x 64.5 cm
Pinacoteca Ambrosiana, Milan

As a present from Cardinal Francesco Maria Del Monte, his patron, Caravaggio's only remaining still life traveled from Rome to Cardinal Federico Borromeo, a great book and art collector, in Milan. In 1607 he donated it to the Accademia Ambrosiana.

The young Caravaggio's move to Rome was a decisive step in the development of the emerging genre of still-life painting. During his time in Milan and his initial artistic training, Caravaggio acquired an interest in nature that was typical of the art and culture of northern Italy in the sixteenth century. In Rome, certain works by Raphael and his school also encouraged an interest in still-life subjects.

With incomparable mastery, Caravaggio painted the leaves and fruits—including grapes, figs, and apples—in different stages not only of maturity and ripeness but also of decay and decomposition. Thus one can see a small hole in the glowing red skin of the apple where a worm has entered to feed on the inner flesh. The message conveyed with these small details is that all living ripeness hides the seed of corruption and decay.

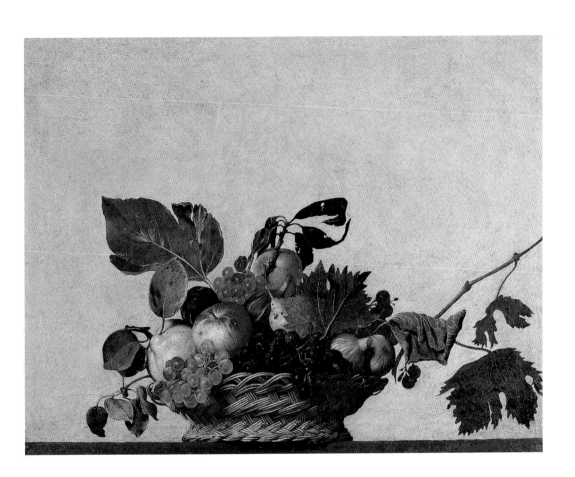

St. Catherine of Alexandria

c. 1598–1599

Oil on canvas, 173 x 133 cm
Museo Thyssen-Bornemisza, Madrid

This picture marks the start of the transition from Caravaggio's early genre paintings to his great altarpieces for Roman churches. During this period he produced works whose figures are bathed in a bright light in front of a mostly dark background. Objects are depicted naturalistically, like the heavy, expensive clothes shown here; their magnificence contrasts strongly with the concept of martyrdom, the palm branch by the feet of the saint being a symbol of a martyr's victory over death.

The other attributes of the saint, for example the wheel on which she is leaning (she was put to death on a wheel) and the sword she holds in her hands (another symbol of martyrdom), are depicted with a vivid naturalism that makes their significance all the more dramatic. They have a physical presence typical of the realism of the Lombardy School.

Caravaggio preferred to paint using live models and not from memory or drawings. For this reason, the same faces appear again and again in different paintings, both in the altarpieces and in the early allegorical and mythological paintings. However, he rarely painted portraits in the classical sense and the few portraits he did create did not achieve the vivacity of his scenes. The courtesan Fillide Melandroni often sat as a model, here for St. Catherine, as well as for Mary Magdalene (*The Conversion of Mary Magdalene*) and Judith (*Judith Beheading Holofernes*)—they have the same facial features, the same reddish blonde hair, the same full lips and dark eyes. Even the dresses are similar in all these paintings: a straight neckline with shoulder straps and a laced bodice with puffed sleeves. Only the expression is different each time. In comparison, the figure in *Portrait of Fillide Melandroni* (also known as *Portrait of a Courtesan*), which was kept in Berlin until destroyed in 1945, and which is known only from photographs, seems stiff and contrived.

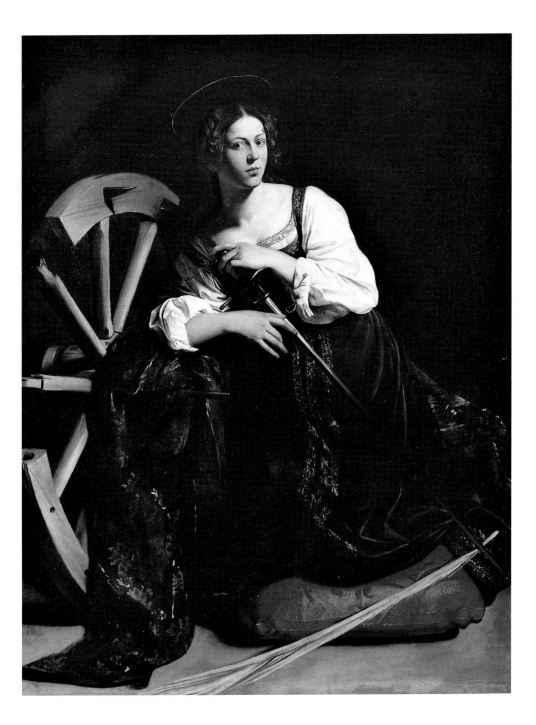

Judith Beheading Holofernes

c. 1599

Oil on canvas, 145 x 195 cm
Galleria Nazionale d'Arte Antica, Rome

In this dramatic painting, Caravaggio seizes on one of the favorite subjects of Italian paint-ing in the seventeenth century: the beheading of the Assyrian General Holofernes by the Israelite Judith. This version, which according to Giovanni Baglione was painted for the banker Ottavio Costa, was created soon after Caravaggio's move to the household of his patron, Cardinal Francesco Maria Del Monte. It belongs to a group of Caravaggio's paintings from the period after 1600 in which he portrayed dramatically charged scenes. Cold clear light falls on the figures and highlights them so strongly that they appear almost three-dimensional. The drama of the scene focuses on the face of the young executioner. With a mixture of cold-bloodedness and revulsion, she gazes intently at her victim, who has opened his mouth in a scream of mortal horror. Next to the young heroine stands an old servant whose features are ravaged with age—the contrasts could hardly be greater. Bright light falls relentlessly on all details of the gruesome scene, the severed neck of the man twisted in the throes of death, the bloody blade of the sword, and the contrasting faces of the women. All looks and gestures are highly charged. Characteristically for Caravaggio, the figures were painted from real life, not from studies or even sketches. The use of a dark background is also typical; this would soon become a trademark of Caravaggio and then of his numerous imitators (Caravaggisti).

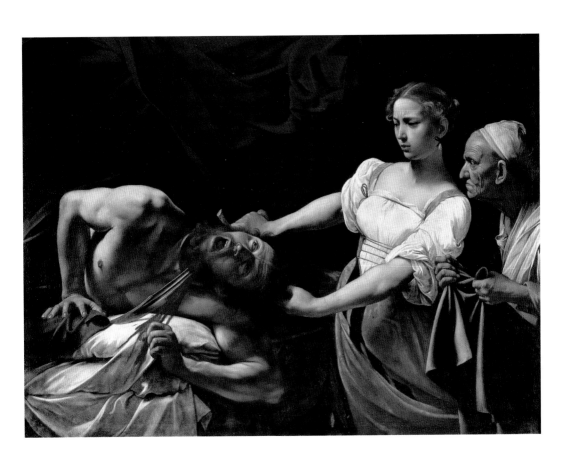

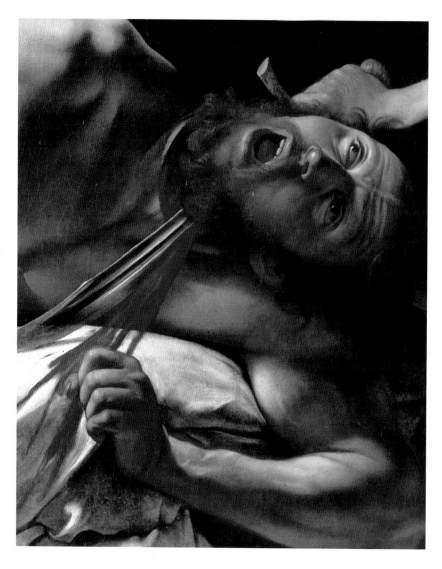

Judith Beheading Holofernes (details)

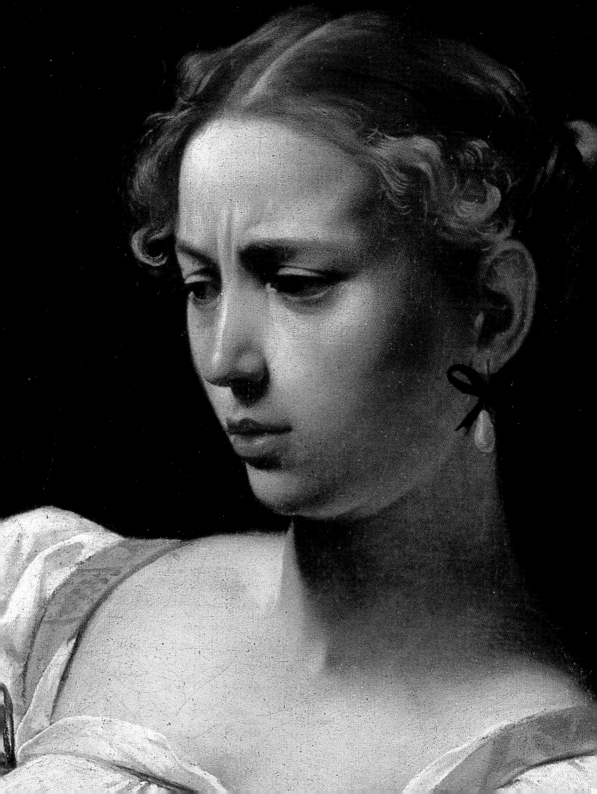

The Martyrdom of St. Matthew

1599–1600

*Oil on canvas, 323 x 343 cm
San Luigi dei Francesi, Rome*

In 1599, with the help of Cardinal Francesco Maria Del Monte, in whose residence he was living, Caravaggio received a commission for three paintings for the neighboring church of San Luigi dei Francesi. Depicting scenes from the life of St. Matthew, they were intended for the Contarelli chapel, the funeral chapel of Cardinal Mathieu Cointrel (Matteo Contarelli in Italian). The three very different images of this so-called Matthew Cycle are among his finest works.

In the course of the gradual creation of the compositions, Caravaggio released himself from the last influences of Cinquecento (sixteenth-century) painting—in the image shown here, which in the chapel is on the right of the altar, the two unclothed figures in the foreground are echoes of this—and found new forms of expression for religious painting in which the dramatic use of light plays a critical role.

As X-rays have unexpectedly shown, Caravaggio reached the final version of *The Martyrdom of St. Matthew* in three sequential stages. Of the three pictures in the cycle, the *Martyrdom* displays the most drama and the fullest range of expressive figures. In the center of the convulsive events are two interlocked figures: the Apostle in the robes of a priest and his semi-naked killer, who has flung him to the ground and stabbed him in the chest with a sword. Caravaggio depicts the terror of the scattered group vividly. He makes us witnesses to the bloody drama, as if the crime were being enacted before our eyes. The saint lifts his hand to defend himself against his murderer, whose mouth, like that of the fleeing altar boy, is opened in a scream. The witnesses who scatter in fear (Caravaggio skillfully borrows details from paintings by Raphael and Leonardo da Vinci here) include the painter himself—the half-hidden face on the left above the executioner bears the deeply etched features of the artist, including his short beard and his tangled dark hair.

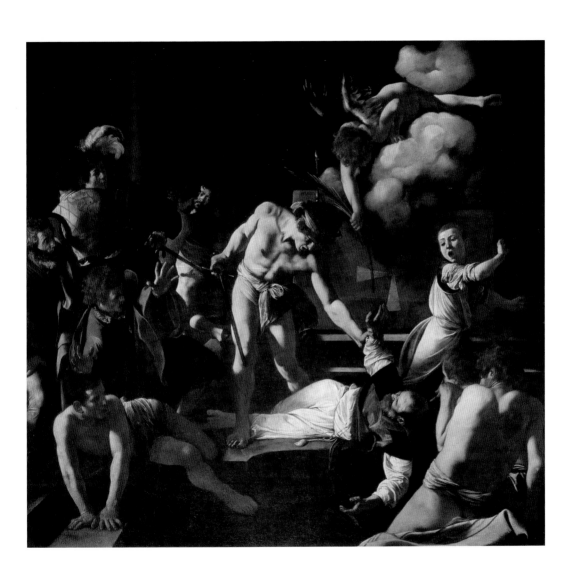

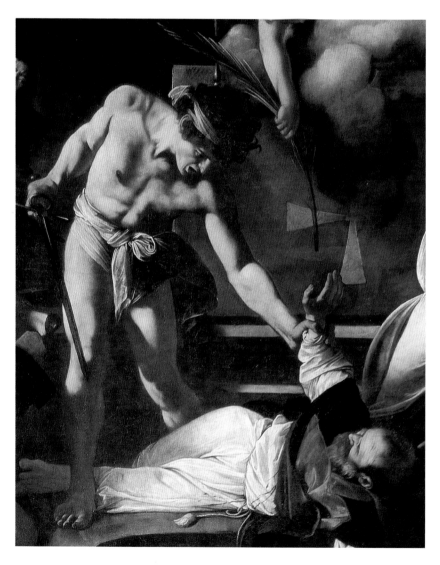

The Martyrdom of
St. Matthew (details)

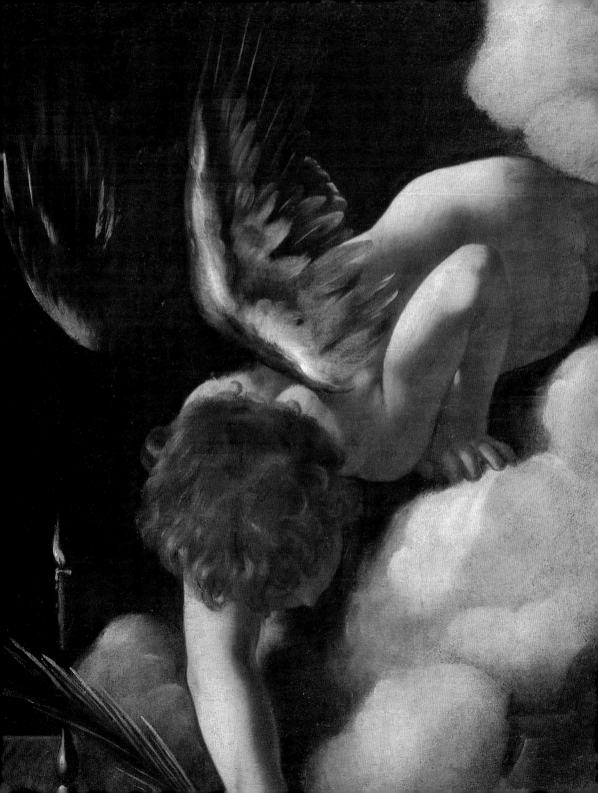

The Calling of St. Matthew

1599–1600

Oil on canvas, 322 x 340 cm
San Luigi dei Francesi, Rome

Although preliminary stages were needed for the final composition of *The Martyrdom of St. Matthew*, Caravaggio created the painting to the left of the altar in the Cantarelli chapel, *The Calling of St. Matthew*, in one go, without significant corrections during painting. The composition, which shows clear references to Venetian painting, is a good illustration of Caravaggio's innovative handling of light, which no longer fills the room as in his early pictures, but instead picks out figures amid the overall darkness, both enhancing the meaning of the incident and deepening its emotional content.

From the right, and largely hidden by the figure of St. Peter, Christ enters the guardroom of the tax collectors and soldiers, who are seated around a table with Matthew. With quiet majesty, Christ points to Matthew with his extended right hand. As in Leonardo's *Last Supper*, which Caravaggio had often seen in Milan, the figures react with very different gestures and expressions. The sharply accentuated light underlines the meaning of the event. Falling from the right onto the rough wall and the dusty window above the group, it illuminates the hand of Christ as well as the questioning reaction of the future Apostle. Symbolically, the light points to the effect of divine grace in the world.

Caravaggio's paintings were often copied. Many painters, however, took only individual figures and themes from his works. Thus groups with soldiers wearing magnificent feathered caps and playing card or dice games became part of the standard repertoire of *Caravaggisti* across Europe.

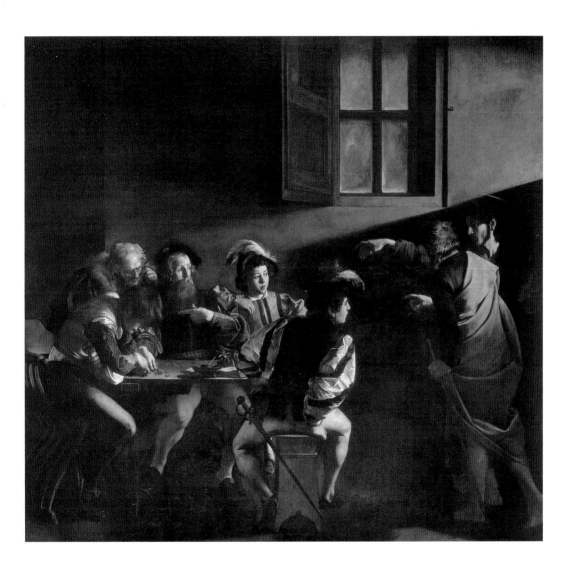

*The Calling of
St. Matthew (details)*

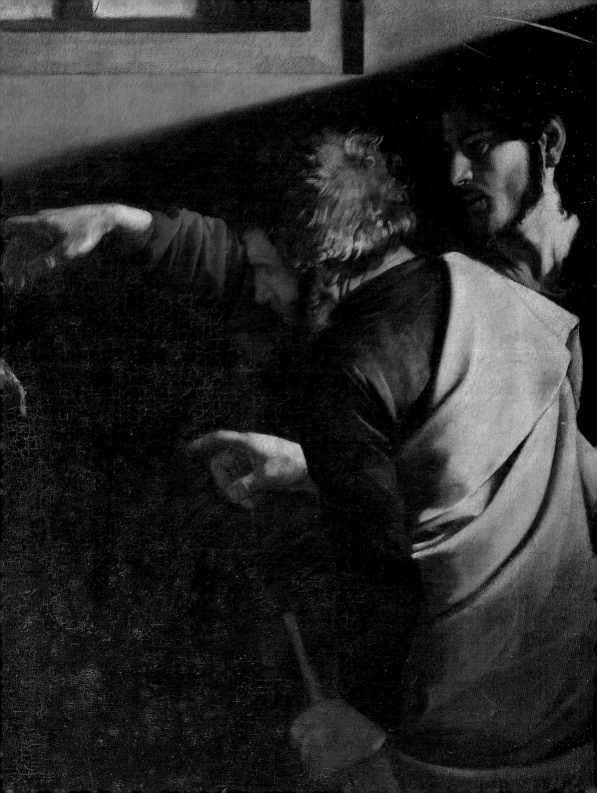

The Conversion of St. Paul

1600–1601

Oil on wood, 237 x 189 cm
Balbi Odescalchi Collection, Rome

While he was still working on the Matthew Cycle for the Contarelli chapel, Caravaggio received a commission for a Conversion of St. Paul and a Martyrdom of St. Peter for the family chapel of Cardinal Tiberio Cerasi in the church of Santa Mario del Popolo in Rome. According to the contract dated 24 September, the painter had to "deliver two paintings on cypress wood panels, ten by eight feet wide, within eight months, for which he will receive 400 scudi."
The first version of the painting depicted, as agreed, Paul's (Saul's) fall from his horse on the Road to Damascus. However, this version was not hung in the Cerasi chapel and Caravaggio had to paint a second version on canvas. (The first version is today one of the most important works by Caravaggio in a private collection.)
The highly moving scene is testimony to Caravaggio's talent both for developing innovative composition and also for capturing human emotions. From the top right Christ enters accompanied by an angel. Paul lies on the ground and covers his blinded eyes with his hands. A bearded soldier tries to protect his master with his shield and lance, while the horse shies away foaming at the mouth. If this version is compared with the second version in Santa Maria del Popolo (see page 81), the figure of the Apostle stretched on the ground appears excessively theatrical, and this may have been the reason why it was refused.

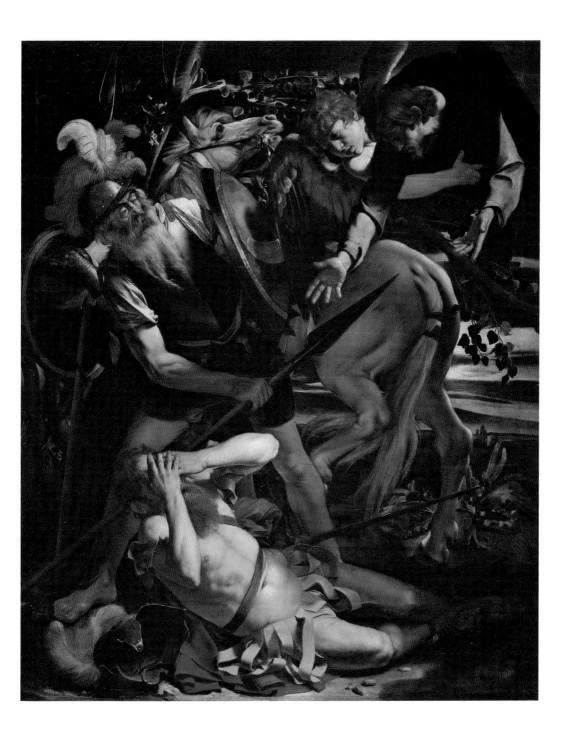

The Martyrdom of St. Peter

1600–1601

Oil on canvas, 230 x 175 cm
Santa Maria del Popolo, Rome

The two paintings depicting scenes from the life of the Apostle Princes Peter and Paul that Caravaggio created for the side walls of the Cerasi chapel in the church of Santa Maria del Popolo in Rome immediately followed his Matthew Cycle in the church of San Luigi dei Francesi, commissioned by Cardinal Tiberio Cerasi. Caravaggio did not receive the commission for the central painting, above the altar. The commission for this work—the *Assumption of the Virgin Mary*—was given to the Bolognese painter Annibale Carracci, one of the most important Roman artists in the early seventeenth century.

Caravaggio's Apostle pictures are closely linked both in form and atmosphere. In *The Martyrdom of St. Peter* it is again the light that isolates the significant features of the drama being played out in an oppressively confined space. The aged St. Peter looks around for help in the darkness. Even the executioner's assistants who are lifting the cross are not shown as inhuman butchers; instead, they are depicted as simple men whose job, which they do not undertake voluntarily, demands exertion and concentration. With a paradox typical of Caravaggio, this human dimension establishes an intimate connection between the executioners and their innocent victim.

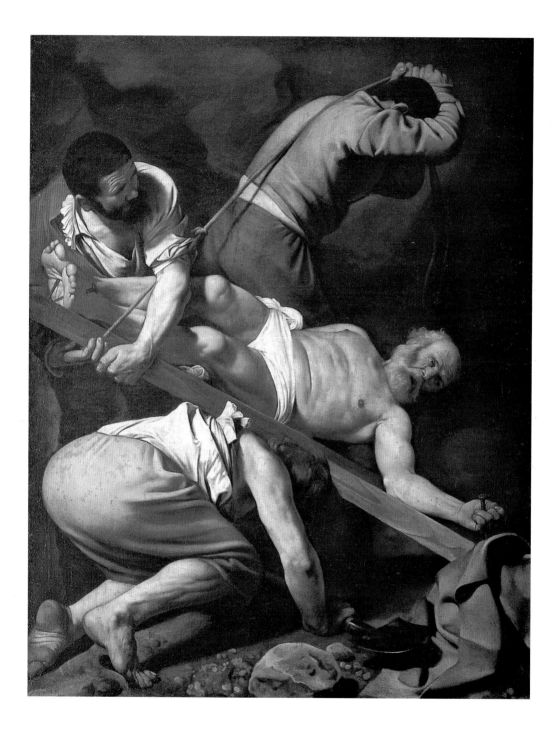

The Conversion of St. Paul

1600–1601

Oil on canvas, 230 x 175 cm
Santa Maria del Popolo, Rome

In the contract for the two Apostle pictures for the Cerasi chapel, Caravaggio was described as the "outstanding painter in the city." In spite of his constant difficulties with the guardians of law and order, he had clearly reached the peak of his early artistic fame.

In *The Conversion of St. Paul*, he relocated the Road to Damascus experience of the future apostle from an open landscape to a dark, indeterminate setting. The massive body of the piebald horse, which a man holds by the bit, dominates the upper half of the picture. In contrast to the dramatic first version now in the Balbi Odescalchi Collection (see page 77), this conversion experience appears to be taking place in silence and in the light of mystical transcendence. No angels or saints appear in a night sky whose darkness is not relieved by the light falling from the top right, a light that brilliantly illuminates the horse and the prostrate figure. A young, clean-shaven Paul (Saul) stretches his arms up, while his eyes are closed. Instead of an animated and highly dramatic scene, we witness an intimate but no less intense encounter with the divine.

Taking his composition from a painting of the same subject by Alessandro Bonvicino, he had seen in the church of Santa Maria presso San Celso in Milan, Caravaggio develops a complex work of great spiritual and emotional depth. The expanse of the horse's body in the upper half of the picture is in stark contrast to the spatial depth in the lower area, where the powerful legs of the horse mingle with the sinewy legs of the groom and the lifted arms of the fallen man.

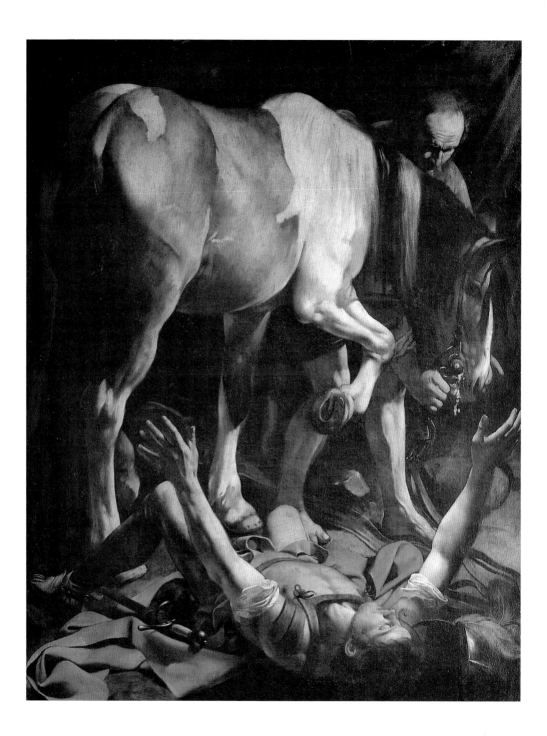

Supper at Emmaus

1601

Oil on canvas, 141 x 196.2 cm
National Gallery, London

This is Caravaggio's first version of the biblical story in which the resurrected Christ meets two of his disciples as fellow travelers on the road to Emmaus, who recognized him as Christ only during the evening ritual of "breaking bread." A second version, today in Milan, was painted in 1606. The date of this London version has not been established conclusively, though it is thought to coincide with Caravaggio's stay in the house of Cardinal Girolamo Mattei, which was during 1601.

In addition to this painting, which was created for Ciriaco Mattei, the brother of the Cardinal, Caravaggio also painted two other works as commissions for the Mattei family: *John the Baptist* (Musei Capitolini, Rome) and *The Taking of Christ* (National Gallery, Dublin).

The relatively early date of this work is indicated by the prominent role given to the still-life elements that adorn the table; the basket full of fruit that hangs precariously over the edge of the table is a clear reminder of Caravaggio's *Still Life with a Basket of Fruit*, which Cardinal Francesco Maria Del Monte sent to the Archbishop of Milan, Federico Borromeo. In contrast, Caravaggio here finds a more precise use for light, which creates sharp contours and deep shadows. In this way, the figures move closer to the viewer, becoming more tangible and substantial. Caravaggio is on the point of redefining the boundaries of painting with the tools of perspective; note, for example, how the arms of the man on the right reach both into the depths of the image and out towards the viewer.

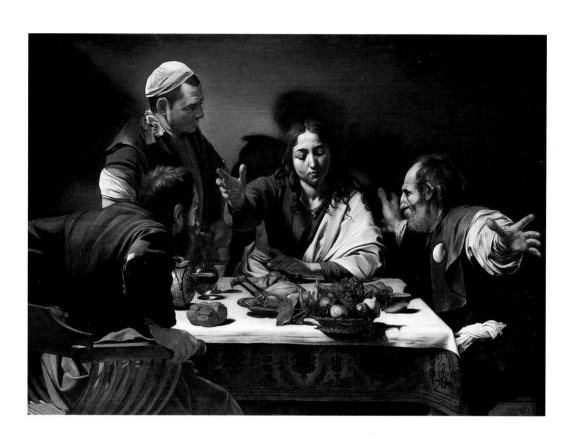

Love Victorious

1601–1602

Oil on canvas, 191 x 148 cm
Gemäldegalerie, Berlin

According to the seventeenth-century painter and writer Joachim von Sandrart, the Marchese Vincenzo Giustiniani, who had commissioned Caravaggio to paint *Love Victorious*, had to cover the painting in his gallery with a green cloth. The intention was to prevent it "stealing the limelight" from the other works in his collection—but more probably to keep it hidden from any visitors who may have taken offence at the joyous nakedness of the winged boy.

In its realism, this is an extraordinarily vivid picture. Even contemporaries, including many poets and scholars, could not resist the fascination exerted by the impudent child god, making the controversial masterpiece a focus for various poems and a range of interpretations. Among these interpretations, the most probable is that the boy, shown with a selection of musical instruments, symbolizes the arts, which means that the work was intended as a flattering comment on the patronage of Giustiniani. In the early inventories of the Marchese's collection, however, the picture is described as a portrayal of the theme of *amor vincit omnia* (Love conquers all), love being a virtue man should nurture as one of most important moral and spiritual qualities.

Whatever the painting's precise meaning, the objects spread out on the floor—including armor, the poet's laurel wreath, a pair of compasses and a set square, a lute and violin—represent typical items from the repertoire of still-life painting in the seventeenth century.

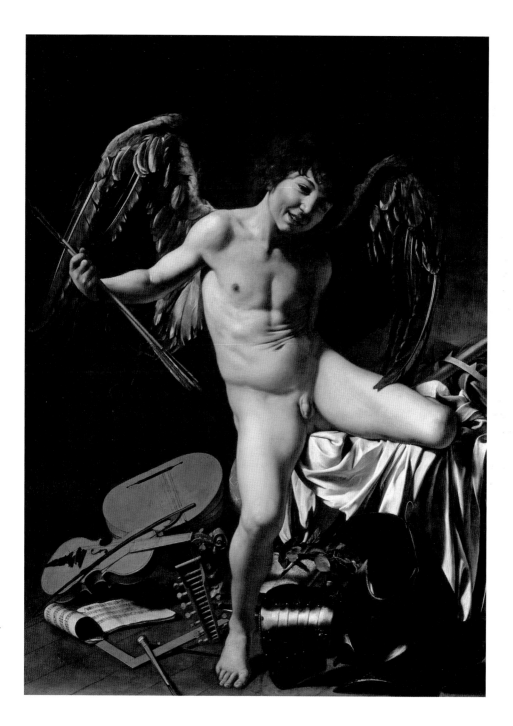

The Inspiration of St. Matthew

1602

Oil on canvas, 295 x 195 cm
San Luigi dei Francesi, Rome

Originally, a marble sculpture of St. Matthew with an angel was intended for the altar of the Contarelli chapel in the church of San Luigi dei Francesi in Rome. However, the work by a rather mediocre sculpture, Jacob Cobaert, did not find favor and so Caravaggio received a commission for an altarpiece with the same subject, that of St. Matthew receiving divine inspiration through an angel. But his first submission was also rejected, and after finishing both paintings for the side walls of the chapel (featuring the Calling and Martyrdom of St. Matthew), he had to create a second version of the central altarpiece. In the first version, apparently rejected because it was "too realistic," the evangelist appears as an old man who is barely able to write the words the angel is dictating to him. His heavy legs are crossed and one foot juts out towards the viewer. This did not prevent the Marchese Vincenzo Giustiniani from immediately purchasing the picture for his collection. It finally entered the Berlin Museum, where it was destroyed in 1945.

In the second version (shown here), the figure of the old Apostle and the book in which he is writing are drawn with the same realism as in the first version, and a precariously balanced wooden footstool juts out of the picture and into the viewer's space. But the exchange of glances and gestures between the two is more meaningful and urgent here. As the model for St. Matthew, Caravaggio used a bearded old man with a bald head and aquiline nose whose likeness reappears in other paintings by the artist from around this time.

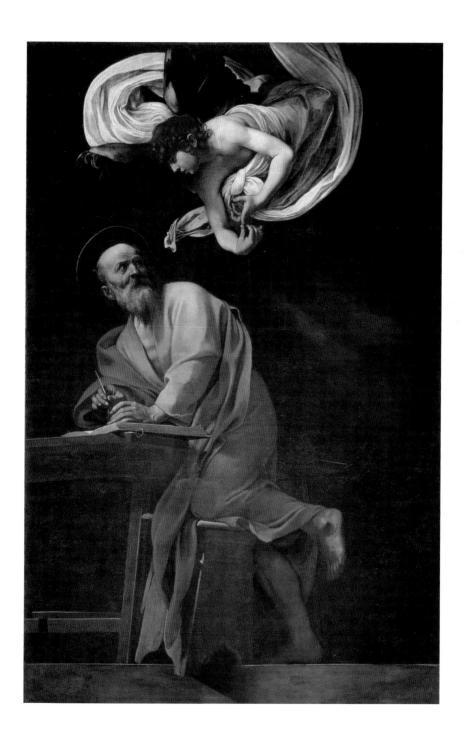

The Taking of Christ

1602

Oil on canvas, 133.5 x 169.5 cm
The National Gallery of Ireland, Dublin

The rediscovery of *The Taking of Christ* is one of the most exciting chapters in modern
Caravaggio research. The painting had been in the possession of the Jesuit College in
Dublin since 1930, but it was considered to be a copy by the Dutch Caravaggio follower
Gerrit van Honthorst. The original was thought to be lost; out of numerous copies and
reinterpretations, only a version in the Museum of Western and Eastern Art in Odessa,
Ukraine, was thought to be quite close to the original. The restoration of the Dublin version,
together with newly discovered documents, confirmed that the picture currently on display
in the National Gallery of Ireland is in fact the long-lost original.

Advice from Cardinal Gerolamo Mattei, the brother of the purchaser Ciriaco Mattei, was
crucial in the choice of the subject and its interpretation as he was Protector of the Francis-
cans and thus able to familiarize Caravaggio with the spirituality of the Order. Betrayed by
Judas and harried by armed men, Christ is almost motionless and seems to abandon
himself to his fate, in accordance with the Franciscan ideals of self-denial and obedience.
The Italian art historian Roberto Longhi, who in 1943 discovered a reference to *The Taking*
in the inventories of the Mattei collection and thus triggered the worldwide search for the
original, recognized the features of the painter in the figure on the far right.

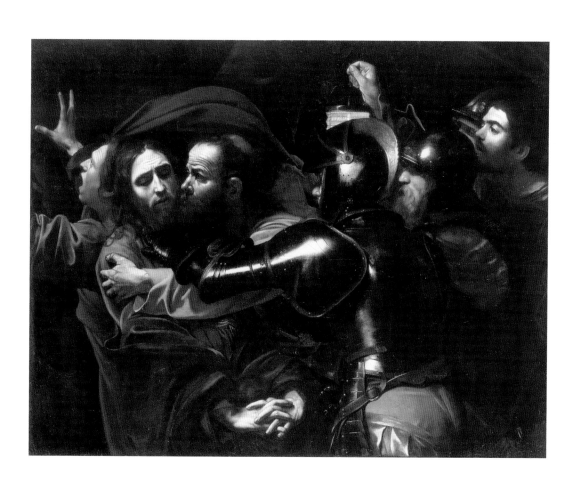

John the Baptist

1602

Oil on canvas, 131 x 98.6 cm
Musei Capitolini, Rome

It was while Caravaggio was living in the house of Cardinal Gerolamo Mattei in Rome that he painted this picture of a boy with a ram for the Cardinal's brother, Ciriaco Mattei, for whom he also painted the Dublin *Taking of Christ* and the London *Supper at Emmaus*. It is traditionally described as a portrayal of the young John the Baptist; the animal skin worn by the figure hints at this, as does the sacrificial animal, which is a traditional symbol of salvation. However, there is still doubt over this identification. In the inventories of the Mattei collection, the picture was listed without a specific title; it was simply described as "a naked youth" and as a "Phrygian shepherd." In fact, the atmosphere of the picture has more in common with the idyllic pastoral world of pagan Arcadia than with the biblical "wilderness of Judah" to which the Baptist withdrew to live off wild honey and locusts. Whoever the true subject, this painting in the Musei Capitolini is certainly among Caravaggio's most light-heartedly sensual. It was created during one of the most carefree periods of his life, which had not yet been clouded by the drama that would soon unfold. The figure, which appears almost three-dimensional, the twisting of the upper body, and the nakedness of the boy allude to historical examples. Caravaggio has even "borrowed" Michelangelo's boy figures in the pedentives of the ceiling frescos of the Sistine Chapel, as well as the muscular figures that Annibale Carraci had just presented to the public in his frescos in the Farnese Palace.

The Entombment of Christ

1602–1604

Oil on canvas, 300 x 203 cm
Musei Vaticani, Rome

Originally intended for the church of Santa Maria in Vallicella, Caravaggio's *Entombment of Christ* is often considered to be a "classical intermezzo" in his stylistic development (even if a comparison with the portrayal of the same subject by his teacher Simone Peterzano in San Fedele in Milan shows that his student had not forgotten the painting style of his home town when in Rome).

The firm composition brings a formal equilibrium to the emotional tension of the event. Caravaggio thus finds a contact point with Roman history painting here, as represented at this time by Annibale Carracci and other Bolognese artists.

The group, shown from below, are standing on a thick grave slab that seems to protrude from the picture plane and that symbolizes the Church born from the sacrifice of Christ. As in Raphael's *Entombment* (1507; Galleria Borghese, Rome) the body of the crucified Christ connects the individual figures and so creates a single, highly animated unit from them.

The burden of the dead body, which the men can support only with great effort, gives the whole picture a dramatic quality. The histrionic gesture of dismay shown by Mary, the wife of Cleopas, who holds her hands up plaintively, contrasts with the formality of the composition.

Caravaggio's *Entombment* became a classic example of the Baroque altarpiece. Peter Paul Rubens copied the work in 1613, though significantly without the emotional gestures.

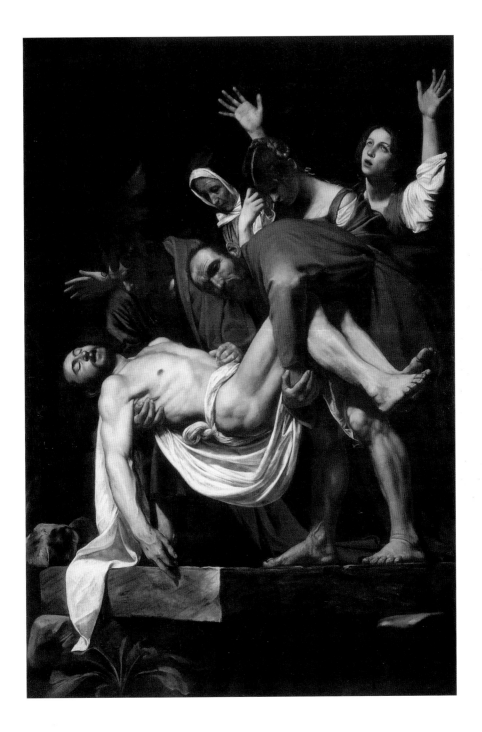

The Sacrifice of Isaac

c. 1603

Oil on canvas, 104 x 135 cm
Galleria degli Uffizi, Florence

Caravaggio depicted the subject of the sacrifice of Isaac by his father Abraham twice in just a few years. This version in the Uffizi was painted around 1603 for Monsignor Maffeo Barberini and, compared to the version in the Piasecka-Johnson Collection in Princeton, displays more drama, with its deep cold colors set against a somber landscape. Abraham has already lifted a knife to the neck of Isaac, whose mouth is open in a scream. Showing the sheer brutality of the scene, it is a stark image that leaves little room for comforting theological interpretations. Caravaggio's power of visual expression comes largely from such realistic, unembellished details.

Old Abraham, who is about to kill his only son, the boy destined to be the victim, the angel who catches the arm of Abraham at the last moment—they are actors in a fateful drama whose pathos is intensified by the urgency in their gestures and expressions. In particular, the face of the young Isaac betrays an alarm that is not recognizable in the figure of the boy in the painting in Princeton. The landscape and the sky contribute to the dramatic atmosphere, and in their realism move away from the influence of Venetian painting. For the figure of Abraham, Caravaggio used as a model the same old man who modeled for the evangelist in *The Inspiration of St. Matthew* in the church of San Luigi dei Francesi, which suggests that the two paintings were created around the same time.

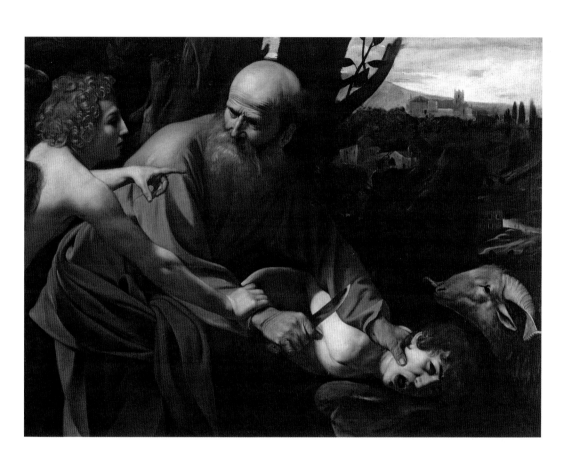

Madonna of the Pilgrims (Madonna di Loreto)

c. 1604–1606

Oil on canvas, 260 x 150 cm
Sant'Agostino, Rome

With this altarpiece for the Cavalletti chapel in the church of Sant'Agostino in Rome, Caravaggio created one of the most extraordinary works of religious painting of the era.

The subject is the Madonna of Loreto. The central Italian town of Loreto revered Jesus's childhood home, which, it was claimed, had miraculously relocated there from Nazareth. The Madonna is standing on a clearly visible high threshold, the Infant Jesus in her arms; in front of her two pious, elderly people kneel in adoration. The scene exudes a modest simplicity and, at the same time, a touching seriousness and intimacy. This Mother of God is depicted as a simple woman of the people, not as the Queen of the Heaven seen in traditional art; a Roman matron standing barefoot on the threshold of a modest house. The two pilgrims have finally reached their destination after a long, exhausting journey and they cannot speak for emotion. They clasp their hands reverently before the divine child, mindless of their dirty feet and shabby clothes. Religious painting had rarely shown such intimate and direct grace.

The *Madonna of the Pilgrims* still decorates the altar in the Cavalletti chapel in the church of Sant'Agostino, near the Piazza Navona in Rome. Unlike other pictures by the controversial realist, this was never banished from its intended sacred setting.

Caravaggio's *Madonna* was soon revered by simple believers too, even though the rival artist Giovanni Baglione noted at the time: "He painted a Madonna of Loreto after nature with two pilgrims, one with dirty feet, the other with a sweaty strand of hair over her face. However, because he had little regard for the elements necessary for a great painting, the people caused a great furor."

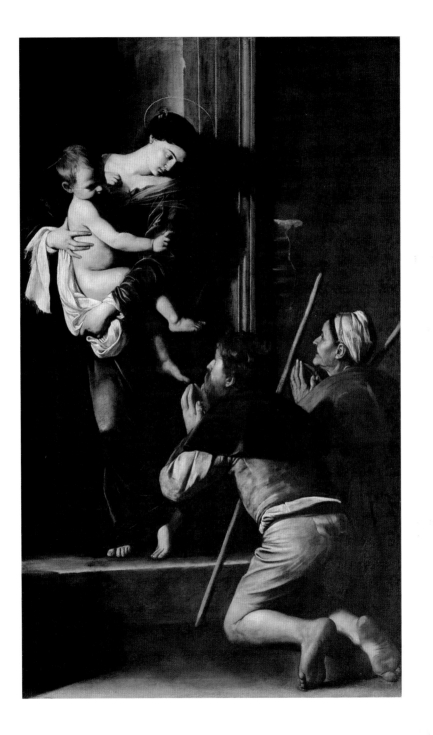

Ecce Homo

1605

Oil on canvas, 128 x 103 cm
Galleria Civica di Palazzo Rosso, Genoa

A contract concluded between Caravaggio and the merchant Massimo Massimi on 25 June 1605 stipulated that Caravaggio was obliged to deliver an Ecce Homo by August of the following year; it was to be based on the same conditions and have the same dimensions as *The Crowning with Thorns* that Caravaggio had already painted for Massimi and that today can be found in the Cassa di Risparmio in Prato, Tuscany. Massimi seems to have been disappointed with the result, for in March 1607 another contract shows that he ordered a painting with the same subject to match Caravaggio's *Crowning with Thorns* from the Florentine painter Ludovico Cardi, known as Cigoli; this picture has also survived and today is in the Uffizi in Florence.

Unusually for a scene of this kind, the painting has a vertical format, probably because it was intended for a private collection rather than a church altar. Bright, clearly graduated light illuminates the three figures standing behind a low balustrade set at the lower edge of the picture. In particular, the athletic body of the Savior, who is naked apart from a loincloth, betrays the influence of the classical canon rarely seen in Caravaggio's work. In contrast, the scornful features of the executioner's assistant, who clothes Christ with a purple cloak, and of the bearded Pilate, who points with a rhetorical gesture to the man in whom he cannot find fault but whom he still hands over to the soldiers for crucifixion, add a tragic and grotesque note.

Ecce Homo was created during the period when Caravaggio had left Rome for some time to avoid the police after violently attacking the notary Mariano Pasqualone.

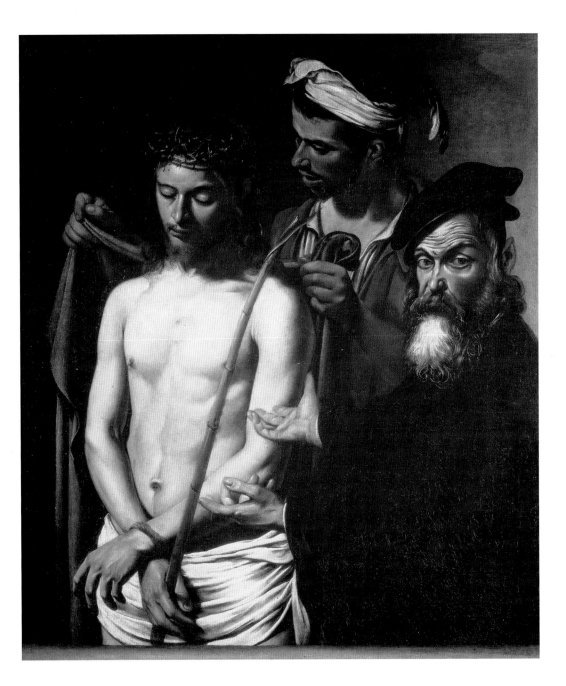

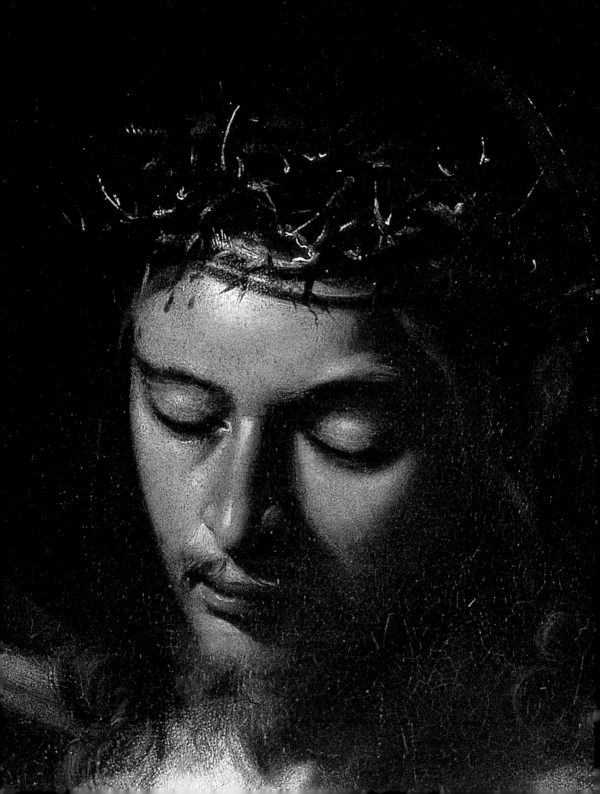

The Death of the Virgin

1605–1606

Oil on canvas, 369 x 245 cm
Louvre, Paris

In his final Roman picture, *The Death of the Virgin* for the church of Santa Maria della Scala in the Trastevere quarter of the city, Caravaggio again demonstrated his unorthodox handling of traditional subjects.

The painting shows the Apostles grouped together at the deathbed of the mother of Christ; Mary Magdalene is in the foreground. Simple people, united in their grief, they occupy a plain, almost bleak setting; above them hangs a deeply folded swathe of curtain, its dramatic blood-red reflected in the dress of the Virgin. The light falls from the top left, illuminating the heads of the mourning Apostles, the body of Mary, and the slumped figure of Mary Magdalene.

What made Caravaggio one of the most important innovators in religious painting of the seventeenth century—the way in which he brought everyday reality in to pictures—was simply too much for the Carmelite monks who had commissioned the painting. For them it represented a too-human portrayal of the dying Mother of God, the way she lies there chalk-white, bloated, her bare feet projecting over the edge of the deathbed. Rumors circulated that Caravaggio had not hesitated to use the body of a prostitute who had drowned in the Tiber as the model for the Holy Virgin.

After the scandalous picture was rejected, it was purchased by the Duke of Mantua, Vincenzo Gonzaga, on the advice of Peter Paul Rubens; from there it came into the hands of Charles I of England before finally entering the Louvre.

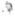

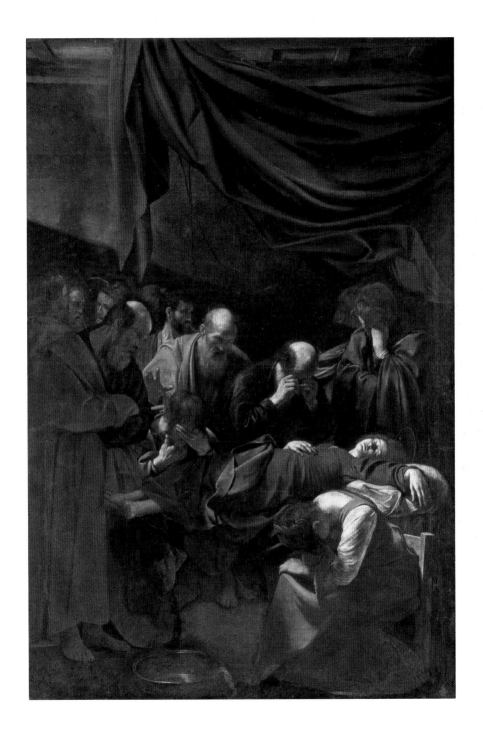

Madonna and Child with St. Anne (Madonna dei Palafrenieri)

1605–1606

Oil on canvas, 292 x 211 cm
Galleria Borghese, Rome

Caravaggio received the commission for this painting from the venerable Arciconfraternita dei Palafrenieri, the Archconfraternity of the Papal Grooms. Originally intended for St. Peters, it was rejected as improper; it too was subsequently purchased by a collector, in this case Cardinal Scipione Borghese, who displayed it in the entrance hall of the Villa Borghese. As the Archconfraternity had specified, the painting shows the Mother of God with the Infant Jesus as they stand on the head of a serpent (sin), accompanied by St. Anne, the mother of Mary and patron saint of the fraternity. Caravaggio strictly adhered to the dogma that the Mother of God had overcome Original Sin only with the strength of her son, which is why they both have their foot on the head of the serpent. Nevertheless, he broke with tradition by giving the allegorical scene an extremely realistic character. Even more impressive is the effect created by the holy figures stepping into the light from the darkness, so that their bodies stand out vividly.

The nakedness of the boy Jesus and the portrayal of St. Anne as an old woman deeply marked by age were obviously just as displeasing to the Papal Grooms as the fact that Caravaggio's disreputable companion Lena Antognetti had modeled as the Mother of God; she may also appear in *The Death of the Virgin*.

Caravaggio had thus lost his chance to be represented in the main church of Catholic Christianity and so be accepted into the circle of artists who participated in the great Roman architecture and art project—the *renovatio urbis*—of the seventeenth century.

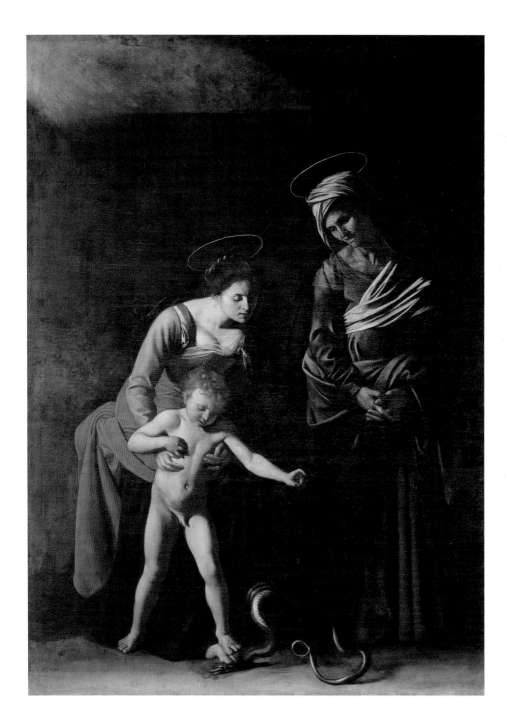

St. Jerome

1605-1606

Oil on canvas, 112 x 157 cm
Galleria Borghese, Rome

In his *Lives of the Artists* published in 1672, Giovanni Pietro Bellori mentions a depiction of
St. Jerome that Caravaggio had painted for Cardinal Scipione Borghese. The picture is also
listed in the inventories of the Borghese collection from the seventeenth century under
the name Michelangelo Merisi, though one hundred years later it was thought to be a work
by the Spanish painter Jusepe de Ribera (1591–1652), who had worked in Naples. Only
from the beginning of the twentieth century has this picture been generally accepted as
a Caravaggio, the art historian Roberto Longhi dating it to 1605–1606.
In this painting, Caravaggio brought together the two pictorial traditions relating to the
depiction of the Church Father St. Jerome: usually he was portrayed either as a learned
author and translator of the Bible in his study, or as a penitent ascetic who had subjected
his body to severe mortification. Caravaggio employed the same model he had already used
for other figures of holy men. Deeply absorbed in reading the holy texts, the Church Father
stretches his thin arm over one of the books spread out in front of him. On the white pages
of a second tome, which is caught in the cold light illuminating the scene, rests a skull as
a symbol of the transience of earthly life. Here Caravaggio formulated a classicism whose
monumentality is based on a portrayal of reality not on an imitation of the past. The
brushwork reveals a spontaneity that is typical of Caravaggio, who painted directly on the
canvas without preliminary sketches or detailed outlines. The goose quill that St. Jerome
holds was painted with a single stroke of the brush.

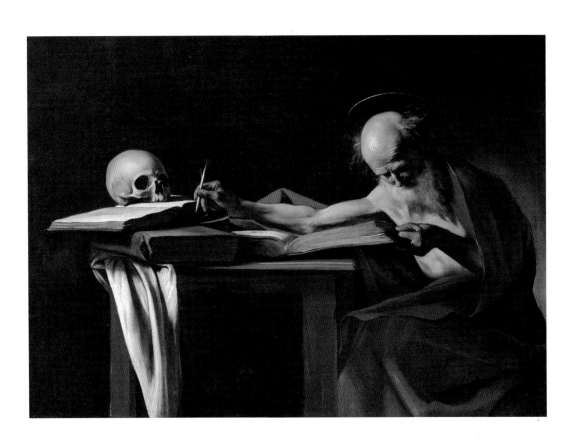

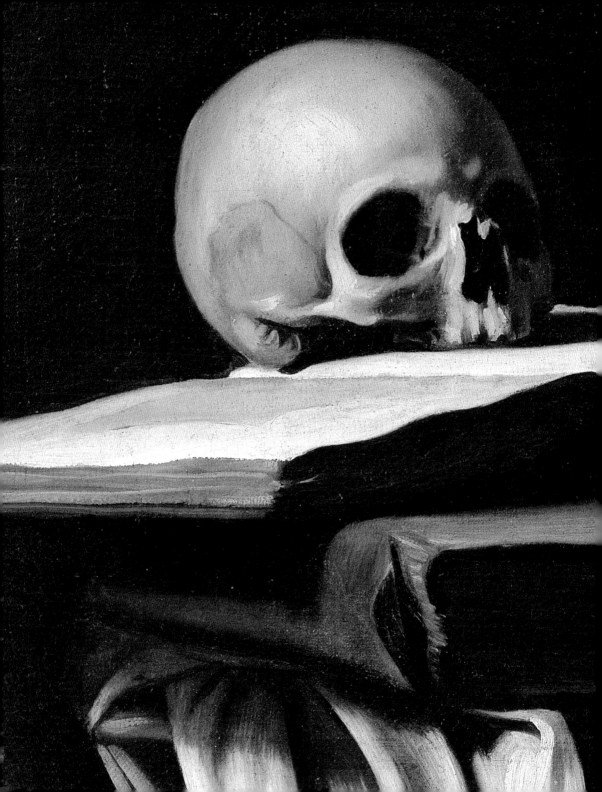

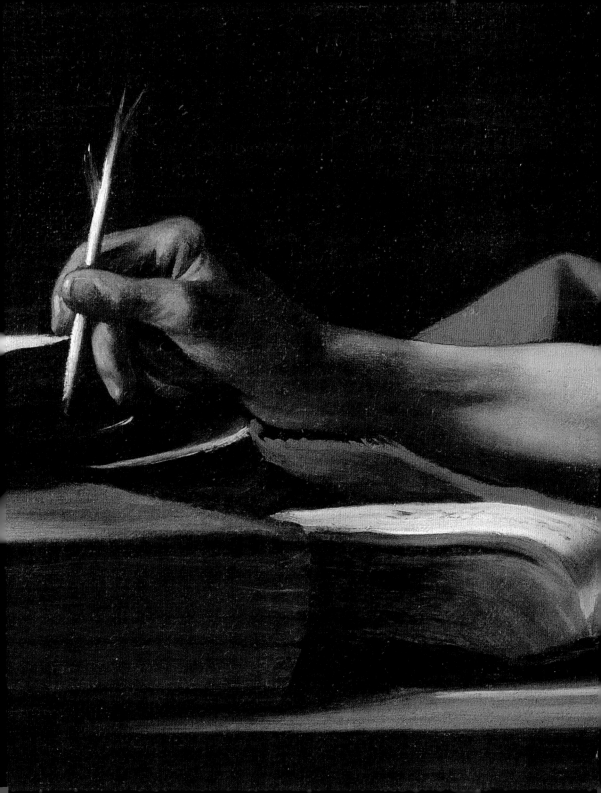

Supper at Emmaus

1606

Oil on canvas, 141 x 175 cm
Pinacoteca di Brera, Milan

The version of the *Supper at Emmaus* that Caravaggio painted in 1606 marked a change in his life and in his art. It was probably painted, or at least completed, on one of the Colonna estates to which the painter fled after killing Ranuccio Tommasoni in a quarrel in Rome. A stark, almost harsh light illuminates the faces and gestures of the figures, who, while being captured in single a moment with the upmost realism, simultaneously express a time-less individuality. In contrast to Caravaggio's first *Supper at Emmaus* (see page 83), which is today in the National Gallery in London, rich earth colors dominate here. The scene radiates intimacy and simplicity. There are no bright colors, theatrical gestures, or bravura still-life elements, as there are in the 1601 version. The bread and simple utensils of a sparse meal can be seen on the table, throwing dark shadows across the white linen. By limiting himself to a few descriptive details, Caravaggio focuses attention on the protagonists' faces, which are sharply etched in light and shadow. The features of the standing couple, whose bodies are largely lost in the surrounding darkness, appear serious and composed, almost melancholy. A mood of parting permeates the scene. As told in the Gospel of Luke, the Disciples recognized Christ only during the evening ritual of the "breaking of bread," and "their eyes were opened and they recognized him; and he vanished out of their sight." Caravaggio depicts the events in such a way that even the details, such as the modest earthenware jug on which there is a subtle interplay of light and shadow, illustrate this spiritual concept of showing and concealing, presence and withdrawal.

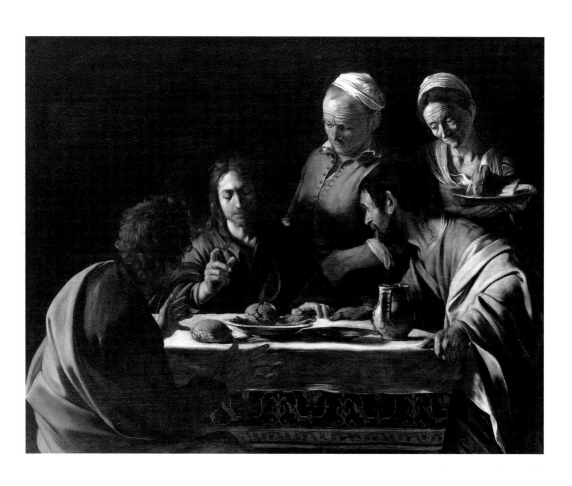

The Madonna of the Rosary

1606–1607

Oil on canvas, 364.5 x 249.5 cm
Kunsthistorisches Museum, Vienna

After spending time at the Colonna country estates in Lazio to recover from the injuries he sustained during the brawl on 28 May 1606, Caravaggio traveled to Naples in September of the same year. There, Luigi Carafa, the son of the Duke of Mondragone and of a daughter of the house of Colonna, took him in. It was probably also Carafa who gave him the commission for an altarpiece, *The Madonna of the Rosary* (though it may possibly have been the Dalmatian businessman Nicola Radulovic). However, the painting was never hung in the chapel in the Carafa house and in 1607 it was sold to the Flemish painter Louis Finson for 400 ducats. The reason why it did not reach its intended destination is unclear. Earlier works had been refused because of a lack of decorum in the portrayal, or because of theologically questionable iconography. The same charges could hardly be leveled at *The Madonna of the Rosary*. With regard to both decorum and dogma, all is correct in this case (with the possible exception of the dusty feet of the kneeling men in the foreground). As on a stage, the Madonna sits with the Infant Jesus in an elevated position under a heavy, folded red curtain tied around a column. Below her stand St. Dominic and several other Dominican monks, including, on the right, St. Peter Martyr. The simple believers kneeling at the bottom of the scene appear to notice none of this. They look towards St. Dominic, who holds out rosary beads to which the Mother of God is pointing; his role is to act as an intermediary between the heavenly and the earthly.

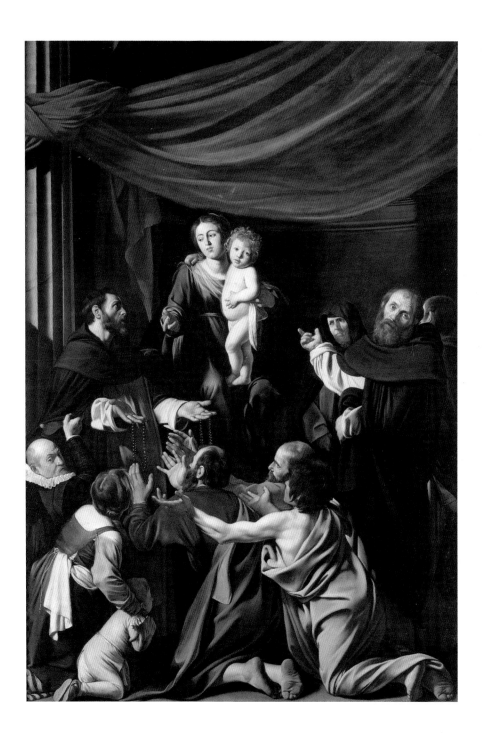

The Seven Works of Mercy

1606–1607

Oil on canvas, 390 x 260 cm
Pinacoteca del Pio Monte della Misericordia, Naples

Painted during his first stay in Naples, Caravaggio's monumental altarpiece for the chapel of the Pio Monte della Misericordia, a traditional brotherhood dedicated to charitable works, became one of the foundation pieces of Baroque painting in southern Italy. Uniquely, it groups together all seven Christian Works of Mercy in a single vivid scene crowded with figures. The Works of Mercy are: to feed the hungry, to give drink to the thirsty, to shelter the homeless, to clothe the naked, to visit those in prison, to visit the sick, and to bury the dead. Unusually, Caravaggio invoked both Christian and pagan sources: like St. Martin, the young man with the feathered hat cuts his cloak with a sword so that a beggar can be clothed; like Samson, the thirsty man drinks from the jawbone of an ass; and like Pero, who gave her father Cimon her breast in prison (an incident from Ancient Roman history), here a young woman feeds the old man behind bars (a theme which is also known as "Caritas Romana," Roman Charity).

At the same time, Caravaggio portrays the events as though they come directly from the turbulent life of the back streets of Naples. Even the Mother of God seems to be gazing down from a balcony. On her arm she holds the Infant Jesus, while two embracing angels fall headlong into the scene, the miraculous and the commonplace intermingling.

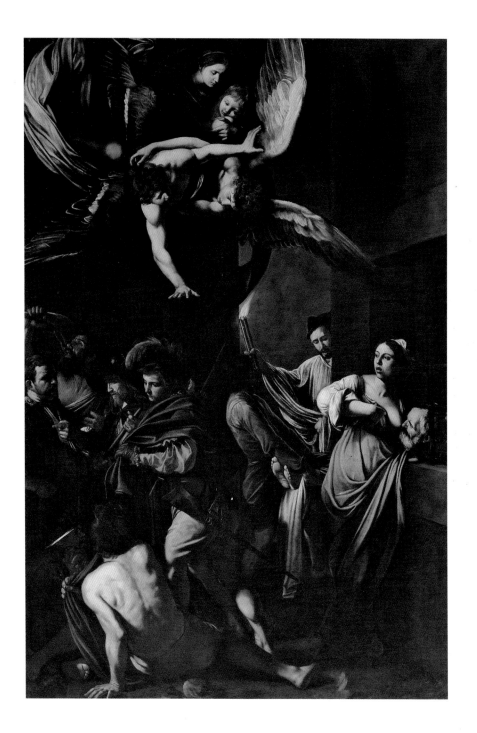

The Flagellation of Christ

1607

Oil on canvas, 286 x 213 cm
Museo Nazionale di Capodimonte, Naples

As we know from a preserved payment note, *The Flagellation of Christ* was intended to be an altarpiece for the church of San Domenico in Naples. In May 1607, the benefactor Tommaso De Franchis paid Caravaggio the substantial sum of 200 ducats for the picture. Later, probably during his second stay in Naples in 1609, Caravaggio made further changes to the picture, correcting the stance of the torturer on the left, for example, and painting over another figure to give the composition greater cohesion.

In fact, Caravaggio alludes to several artistic precedents in his version of this subject, in particular a fresco by Sebastiano del Piombo in the church of San Pietro in Montorio in Rome, and Titian's *The Crowning with Thorns* in the church of Santa Maria delle Grazie in Milan. However, Caravaggio's *Flagellation* achieves an incomparable power of expression. The contrast between the resplendent athletic body of the flagellated man and the dark forms of his tormentors, who have half disappeared into the shadows, is just as vivid as the contrast between the smooth features of the Man of Sorrows, who is silently resigned to his fate, and the face of the executioner twisted into a grimace as he takes hold of the hair on the nape of his victim's neck. The vertical folds of Christ's loincloth follow the lines of the column to which he is tied. As with all subsequent painting, in particular with those created in Naples, Caravaggio uses an almost black background against which to set brightly illuminated features and so create strong contrasts.

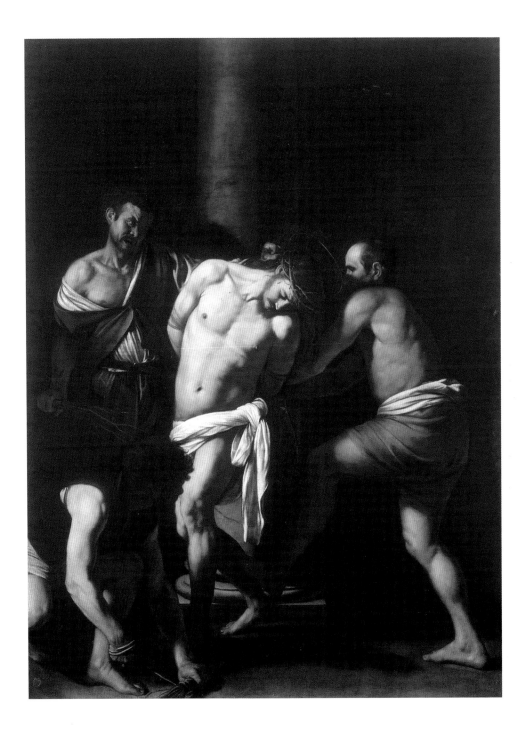

The Martyrdom of St. Andrew

c. 1607

Oil on canvas, 202.5 x 152.7 cm
The Cleveland Museum of Art, Cleveland

Caravaggio's *The Martyrdom of St. Andrew* depicts the moment when the Roman proconsul Egeas, shown in helmet and armor, gives the order to take down the Apostle from the cross following the clamoring of the crowd; but the martyr is beyond saving. His crossed legs hint at the traditional X-form of a St. Andrew's cross, which here, with the freedom of a creative artist, Caravaggio replaced with the traditional upright form. Also unconventional is the expression of helpless pain the painter has given to the figure of the dying man, whose gaunt body is unprotected from torment.

The man in dark, shining armor and the visibly aged woman who looks towards the cross belong to Caravaggio's standard repertoire of figures; they return in other pictures by him, as well as in pictures by his numerous imitators in Neapolitan painting of the seventeenth century. The high number of copies of *The Martyrdom of St. Andrew* made identification of the original difficult. Based on stylistic analysis—of the highlights that fall only on specific features, for example—researchers today tend to date this work to Caravaggio's first stay in Naples, and to identify it with the painting that, according to Giovanni Pietro Bellori, was owned by the Count of Benavente, Don Juan Alfonso de Pimentel y Herrera, who held the office of the Spanish Viceroy to Naples from 1603 to 1610.

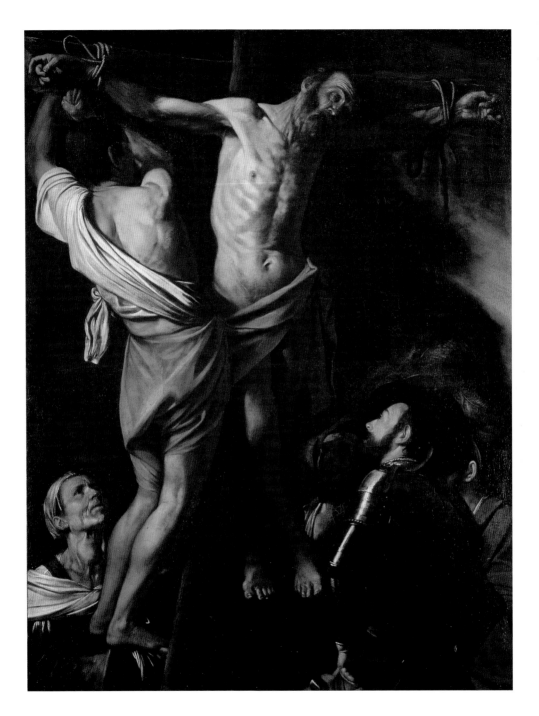

The Beheading of St. John the Baptist

1608

Oil on canvas, 361 x 520 cm
St. John's Co-Cathedral, Valletta

Caravaggio's largest work is also the only one he signed with his own name (in the blood
that runs from the neck of John the Baptist). This monumental beheading also marks
a final stage in Caravaggio's stylistic development. The radiant colors and precise details of
his Roman years have disappeared; only the dramatic blood-red robe of the Baptist is an
exception here. From now on, the focus of his compositions was space, more specifically
how events are enacted within a given space. In this painting, the active figures are grouped
together on the left, while on the right, in front of a gloomy wall, gapes the emptiness of
a dingy prison yard. John the Baptist lies beheaded on the ground, the executioner bending
over him to finally cut the head from the body with the knife he is taking from his belt. The
jailer points to the golden bowl held ready by a servant to take the head of the Baptist to
Salome. Horrified, an old woman hides her face in her hands. A comparison of this gesture
of horror with the theatrically raised hands of the lamenting Mary, wife of Cleopas, in *The
Entombment of Christ* of 1602–1604 (see page 95) shows the concentration of expression and
psychological depth Caravaggio achieved in the last phase of his work.

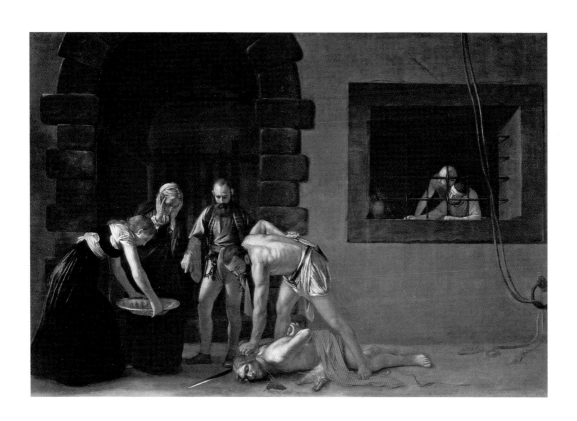

The Burial of St. Lucy

1608–1609

Oil on canvas, 408 x 300 cm
Santa Lucia, Syracuse

After his adventurous flight from the dungeons of the Knights of Malta, Caravaggio reached Sicily. In Syracuse, his fellow artist Mario Minniti, whom he had known from Rome, gave him a commission from the Senate for an altarpiece for the church of Santa Lucia; the painting is still in its intended location today. In spite of its poor condition, the monumental *Burial of St. Lucy* is one of the most important contributions Caravaggio made in his later years to the art of the altarpiece.

The delicate body of the young saint lies near to the lower edge of the picture; above it bend the massive bodies of the two grave diggers. Contrasts such as these—together with the light falling from the side and the pathos of the ceremonious gesture of blessing made by the Bishop, who raises his white gloved hand—give the picture deeply poignant aura.

The arrangement of the figures in the picture area is unusual; they are almost life-size, yet fill only the lower area of the composition. Above the group of mourners broods an immense empty space. Typically, Baroque painters filled such spaces with angels and saints. Caravaggio, however, does not avoid the burden and oppressive sadness of the moment.

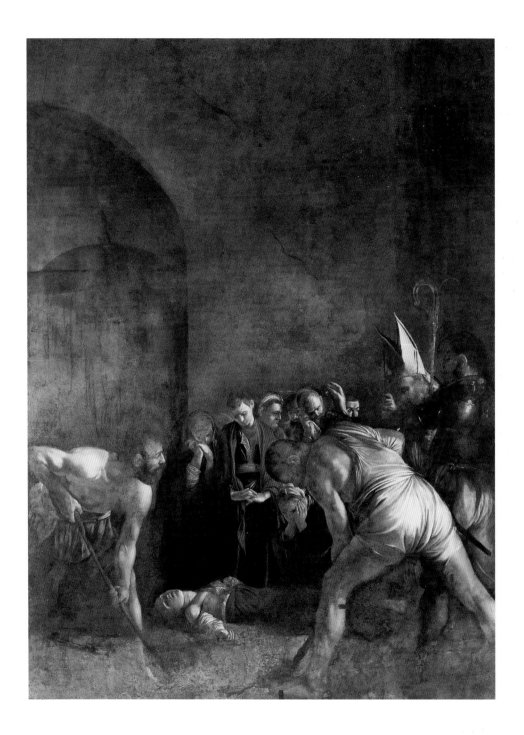

The Raising of Lazarus

1608–1609

Oil on canvas, 380 x 275 cm
Museo Regionale, Messina

Caravaggio painted this picture for the church of the Padri Crociferi in Messina as a commission from the Genoese businessman Giovanni Battista de' Lazzeri, whose family name is thought to have inspired the subject. The Messinese chronicler Francesco Susinno reports that when Caravaggio insisted on using a real corpse as a model, his assistants, who had to hold the body in position, complained strongly. When the Lazzeri family accepted the completed painting with little enthusiasm, Caravaggio is supposed to have damaged it with a knife, but then reworked and retouched it.

The scene of the raising of the dead Lazarus by Christ, as described in the Gospels, was for Caravaggio a gloomy event that must have seemed like a meditation on the triumph of death rather than the promise of life. Instead of appearing like a dead man brought back to life, Lazarus looks as though still held tightly in the grip of death, his limbs projecting stiffly as the shrouds fall away. The pathos of Jesus masterfully pointing his finger to the dead man is a reference to his earlier version of *The Calling of St. Matthew*. The subdued earthy colors and the dark, empty space before which the figures are positioned are recurring features in Caravaggio's last works.

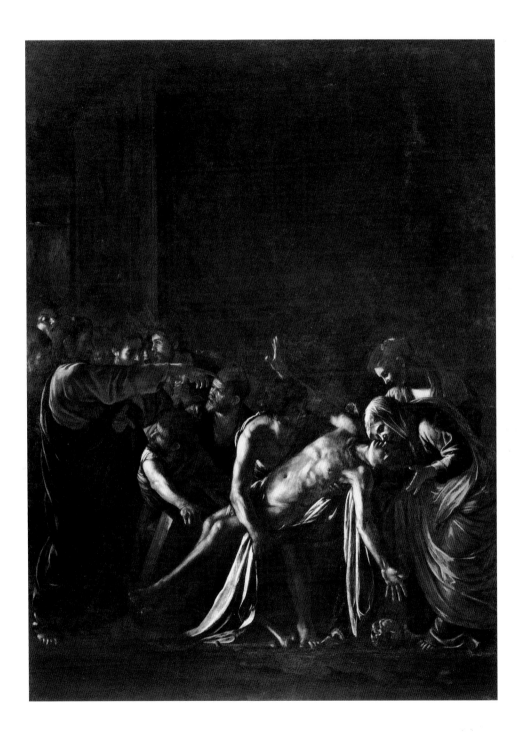

The Adoration of the Shepherds

1609

Oil on canvas, 314 x 211 cm
Museo Regionale, Messina

The bare, almost naked scene, the tools and straw on the ground, the figures of the simple shepherds leaning towards the child and his mother, who nestles the newborn to her cheek gently, are all themes intended to direct the attention of the viewer to the intimate human dimension of the mystery of the Incarnation. Instead of the intensive colors and clear forms of his earlier works, the painting concentrates on the emptiness of the space in which the figures are placed. The other works Caravaggio painted in Sicily—*The Burial of St. Lucy* in Syracuse and *The Raising of Lazarus*, also in the Museo Regionale in Messina—have a similar character.

From a distance, the timberwork of the stable and the low light suggest Tintoretto's paintings for the Venetian church of San Rocco, works which the young Caravaggio had been able to see on a journey to Venice in the company of his teacher Simone Peterzano (though the poor condition of the Messinese *Adoration* makes a direct influence difficult to establish).

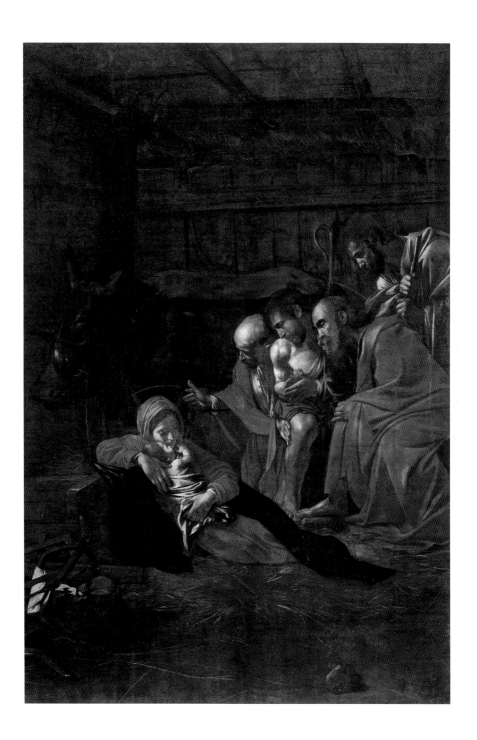

David with the Head of Goliath

c. 1610

Oil on canvas, 125 x 101 cm
Galleria Borghese, Rome

The theme of decapitation seems to have obsessed Caravaggio—hardly surprising given his status as a wanted man—and it appears again in this late and masterful painting. It shows David holding the severed head of the Philistine Goliath by the hair. The figure of the young hero, largely inspired by classical sculptures, emerges vividly from the pitch-black darkness of the background. With an almost melancholic expression, David gazes at his trophy, from which blood still runs.

Goliath's features have been identified as those of Caravaggio himself, this work being seen as a late "self-portrait." Psychological studies of Caravaggio have suggested that the pictures he painted while on the run express an unconscious desire to be punished for the crime he had committed—and perhaps also for his unconventional and unstable way of life. So this painting for Cardinal Scipione Borghese could be regarded as an admission of guilt and a plea for forgiveness that the artist wanted to send to Rome from Naples. More prosaically, Caravaggio probably wanted to express his gratitude to the Cardinal, who had worked hard to secure a pardon for him.

The sketchy brushwork, particularly of the garments, also indicates that the figure of David was painted during the final stage of Caravaggio's career. The painting has been part of the Borghese collection since 1613.

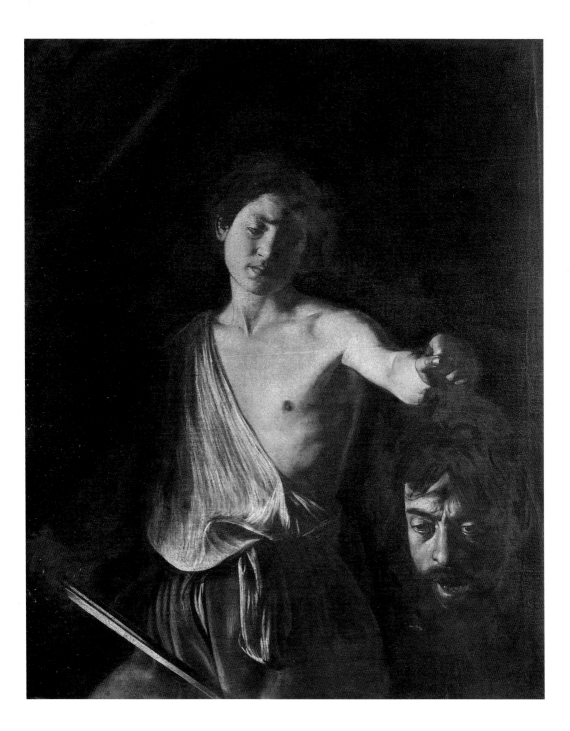

The Martyrdom of St. Ursula

1610

Oil on canvas, 143 x 180 cm
Banca Intesa Collection, Naples

The last painting mentioned in a document created during Caravaggio's lifetime is *The Martyrdom of St. Ursula*, which he painted during his second stay in Naples for the Genoese prince Marcantonio Doria.

The saint receives the fatal wound with complete equanimity. Her calm face, illuminated by silvery light, is in stark contrast to the grimace of her murderer, who stands before her frightening close, as if he had just let his arrow shoot from the string of his bow. Caravaggio had portrayed numerous martyrs during his lifetime and used a number of moods and expressions. They range from the explosive outbreak of violence in *The Martyrdom of St. Matthew* to the intimate relationship between perpetrator and victim in *The Martyrdom of St. Ursula*. With an expression of surprise, but without visible agitation, the saint looks to the wound in her breast, from which blood pulses in thin spurts. Everything appears to take place in silence. A few figures can be identified in front of a dark background. The colors are defined by earthy tones; only the tunic of the marksman and the robes of the martyr glow in red tones. It is the sharp accents of the chiaroscuro, so typical of Caravaggio, that create the drama of the moment.

With the figure looking upwards behind the saint, Caravaggio painted his own portrait for the last time.

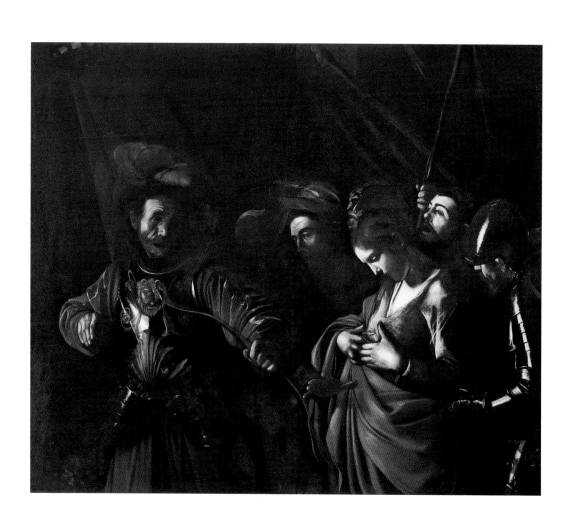

THE ARTIST AND THE MAN

Caravaggio in Close-Up

Caravaggio's image in art and literature

Unusually for a painter of his era, Caravaggio did not paint a formal self-portrait. Instead, he portrayed himself as figures in his paintings, and always in dramatic situations. These images, which mark the course of his life, show him as a pale, sickly boy displaying signs of malaria (to which Caravaggio supposedly finally fell victim); as a man aged around thirty, the witness to a murderous attack on an old priest; a short time later, as a man with a lantern in his hand among a group of henchmen who have set out to attack a man with clubs and swords; as a powerless and silent witness to the killing of a young woman; and finally, at the end of his life, as a disfigured Goliath, his head severed from his body.

Caravaggio's likeness was also captured in two drawings by Ottavio Leoni, an artist with sound abilities who was Caravaggio's accomplice in many escapades. It is assumed that they very accurately convey Caravaggio's features. Some informative details are recorded by Caravaggio's early biographers, even though they were often (and usually deliberately) unflattering. Even his appearance was cited as an index of a man tormented by "dark" forces. Giovanni Pietro Bellori, author of a comprehensive collection of biographies in the style of Giorgio Vasari, and a tireless advocate of classicism in art, commented on Caravaggio's naturalism with undisguised contempt. He described Caravaggio as a man of "dark appearance, his eyes dark, his brows dark, and his hair"; elsewhere he made the terse comment that Caravaggio was "short in stature and ugly of face." Giulio Cesare Gigli, who was not a great author but who knew Caravaggio personally, wrote five years after the painter's death that the artist had been equipped "with great, if also somewhat

strange, inventiveness," and that he had a pale face and curly hair, his eyes lively and deep-set.

Karel van Mander gave more details in his *Schilderboeck* of 1604 when he wrote a finely observed description of the artist and the man: "He came from poverty and has worked his way up in life by working hard, facing everything with courage, like those who do not want to be held back by despondency ... however, one must take the rough with the smooth, and with his volatile spirit he could not keep to his art: after two weeks of work, he would wander around for two months, his rapier in his belt, a page by his side. He goes from one playing field to the next and is always making deals so that no-one wants to have anything to do with him."

Caravaggio's early years in Rome

Caravaggio's early years in Rome were hard. He had no money and no one to support him. He struggled with serious attacks of malaria and he had to kept his quick temper in check. This period is clearly reflected in one of his best-known early Roman works, the *Sick Bacchus* "self-portrait" in the Galleria Borghese. Most of what we know about Caravaggio during this period comes from the biography written by the Siennese doctor and art lover Giulio Mancini, who published his account ten years after the artist's death. Caravaggio, it seems, first lived in the house of a Monsignore Pandolfo Pucci; in return for this hospitality he painted copies of devotional images, but he was also required to run errands. According to Mancini, for Caravaggio the worst thing about this arrangement was "that the head of the house was content to eat only salad for the evening meal—for starter, main meal and dessert!" Caravaggio subsequently spent some time with a "poor

man's painter" from Sicily called Lorenzo, about whom little else is known. He employed Caravaggio as an assistant and paid him "a *grosso* for each head." Here Caravaggio must have attained an ability to paint without preliminary sketches (he did not learn it under his Milanese teacher Simone Peterzano), a skill he would employ throughout his career. It probably helped him obtain a place in the workshop of the nobleman and painter Antiveduto Grammatica from Sienna, a position which, though modest, gave him his initial access to the art collectors of Rome.

Caravaggio's economic and social standing changed for the better when the young but already exceedingly successful painter Giuseppe Cesari noticed him. Cesari, who was widely known as the Cavalier d'Arpino, and who suited the contemporary tastes of the late Roman Cinquecento (sixteenth century) with his elegant (for the modern observer sometimes rather anemic) Mannerist paintings, lived near the Palazzo Borghese. During the eight months he worked for him, Caravaggio was mainly employed painting flowers and fruit motifs for the Cavalier d'Arpino's large-scale paintings. In doing this he developed a superb facility for painting still-life subjects, a genre that was just emerging and that, as a result of the major contribution made by Caravaggio, soon found its own independent character and status.

However, Caravaggio was still a long way from success. When he was taken to the Ospedale della Consolazione following a kick from a horse, he did not return to work with Cesari; possibly a rivalry between the established artists and the ambitions new comer was already beginning to reveal itself. Caravaggio changed his lodgings several times, becoming familiar with the worlds of Rome's bustling streets and alleys, full of colorful and often dubious characters: vagrant soldiers, pickpockets, cardsharps, and gypsy girls, both seductive and sly—they all appear in Caravaggio's paintings from this period.

Gradually his works began to be noticed. The credit for discovering Caravaggio's talent goes to the Venetian Cardinal Francesco Del Monte. A cultivated man—highly educated and enthusiastic about art and music—he lived in the Palazzo Madama near the church of San Luigi dei Francesi. The acceptance of Caravaggio into the Cardinal's household in the winter of 1595–1596 marked a crucial turning point in his career. One of the most important men in the Roman Curia, Del Monte was a friend of Cardinal Federico Borromeo (the Archbishop of Milan and cousin of Carlo Borromeo) and a supporter of new trends in culture and science; Galileo Galilei, who was viewed with deep mistrust by the Inquisition, enjoyed his protection. With his influence in the Curia and on the building of St. Peters, and as a trustee of the Grand Duchy of Tuscany for the Pope, he could help his protégé to obtain the public contracts that were so important for the many artists trying to get ahead in Rome. For the twenty-five-year-old Caravaggio this meant an end to his difficulties and the beginning of the ten most glorious years of his career. In spite of all obstacles, failed projects, tensions, quarrels, and court cases that clouded these years, Caravaggio became one of the most sought-after painters in Rome between 1596 and 1606.

Caravaggio's painting technique

Caravaggio had devised a characteristic painting technique that served him well throughout his career. Apart from a wall painting in oils and a few pictures painted on wood, Caravaggio painted with oils on canvas. He was not par-

ticular when choosing his canvases; he even painted over other pictures and once used a linen table cloth. It is unusual that we do not have a single drawing done by his hand. This does not necessarily mean that he worked completely without drawn sketches and detail studies, but that for him the drawing aspect of painting was obviously of lesser importance. Like Titian, who marked the basic lines of his painting on the canvas with a wet sponge, Caravaggio devised his own method for setting out the structure of his compositions. First he painted the ground on the canvas in light gray, reddish brown, or even black. Then—and this was the unique aspect of his painting technique—he scratched fine lines in the ground with the handle of a paintbrush to define the size and disposition of the most important picture elements. These lines are called "incisions" (*incisioni*) by researchers and their existence was not discovered until the twentieth century, when X-ray images and photographs using oblique light were taken during extensive scientific analyses of his paintings.

Clashes with the law

Much of what we know about Caravaggio comes from seventeenth-century biographies and official reports, and it is highly probable that his critics enthusiastically embellished the legends of the dissolute life led by the painter. Moreover, they often had to rely solely on hearsay. So it is claimed that the young Caravaggio had already come into conflict with the law in Milan (some even spoke of a murder), but there are no documents on file. By contrast, in the archives of the Roman papal police there are a number of documents that detail charges against the painter. These include agitated exchanges with the police, the unautho-

rized possession of weapons, incitement of public unrest, and violence against property and persons. Caravaggio was often a guest in the Governor's jail at Tor di Nona on the outskirts of Rome, or in the cells under the jurisdiction of the Senate; his noble patrons had to keep him from the clutches of the law more than once. The watchmen who did their rounds in the area of Piazza Navona knew him well. And he knew them: "The wretched Corporal, whenever he sees me he comes to me with an insolent remark," said Caravaggio in an interrogation record from 1604. According to the files, a more serious incident occurred when Caravaggio attacked a certain Gerolamo Stampa on 19 November 1600, first with a stick and then with a sword, so that he suffered an injury and "a tear in his coat." This time it was Cardinal Del Monte who made sure that the incident was forgotten. Caravaggio was picked up several times by the papal police, sometimes because he was out and about with persons of a dubious nature, sometimes because he associated with prostitutes, and once because of the suspicion of homosexuality was raised—on the whole trivial incidents that could be quickly resolved.

The situation became more serious when Caravaggio was charged with libel and slander by a fellow painter. On 28 August 1603, Giovanni Baglione made a complaint to the police about Caravaggio and three of his associates, the painters Orazio Gentileschi and Filippo Trisegni, and the master builder Onorio Longhi. The cause was a crude and offensive satirical poem that the men composed about Baglione and then circulated. Caravaggio was arrested, imprisoned in Tor di Nona, and questioned. Of course he denied having anything to do with the offensive "Pasquill" (abusive text), though he openly expressed his contempt

for Baglione as an artist. He knew and condemned all of his pictures, including the latest one, a Resurrection of Christ, which he thought was the worst of all. According to Baglione, it was jealousy of this painting in the church Il Gesù that had upset his rival. On the contrary, Caravaggio replied, he had never heard another painter speaking in praise of Baglione's abilities. Baglione was certainly no genius, but as a painter he had his qualities. As the author of one of the first biographies of Caravaggio, he took full advantage of the opportunity to give Caravaggio a taste of his own medicine.

This episode throws significant light on the Roman art scene at the beginning of the seventeenth century, as well as on the conversational tone and atmosphere of aggressive rivalry that characterized the search for important commissions. The records from Tor di Nona are also the only written testimonies that we have by Caravaggio. They include some informative statements he made on works by other painters and on his own ideas on the nature of painting. For example, during one interrogation he stated that a good painter was one who insists on painting and imitating things "according to nature."

Without the case coming to court, Caravaggio was released from the prison at Tor di Nona on 25 September after the French ambassador spoke in his favor—released on condition that he "didn't leave his home, otherwise he was under threat of the prison ship."

Versions, copies, and authenticity

During his first decade in Rome, Caravaggio painted mostly everyday (genre) scenes for aristocratic collectors and he himself painted copies of his more successful works. The most famous examples are the two versions of the *Boy Bitten by a Lizard* (Fondazione Longhi, Florence, and National Gallery, London), of *The Fortune Teller* (Musei Capitolini, Rome, and the Louvre, Paris), and of *The Lute Player* (Hermitage, St. Petersburg, and the Metropolitan Museum, New York). In addition, there are also countless other versions and copies of known works by the artist, mainly in private collections and provincial galleries, their dating, attribution, and authenticity matters of dispute. At the turn of the seventeenth century, the art market was experiencing a rapid and turbulent development. It was common practice to create replicas of famous paintings. However, Caravaggio seldom limited himself to simply repeating a finished painting. Often there are small but significant differences between different versions of the same subject. The situation is different, however, with the numerous copies that other, often mediocre, painters created based on his works, though without achieving anything of the original's power of expression.

In addition, though Caravaggio's altarpieces created after 1600 are well attested in documentation (some even with surviving contracts), for the period prior to this there are hardly any records of the work of Michelangelo Merisi/Caravaggio. This also makes it difficult to date the early Roman works in order of their creation. At that time, as today, numerous copies of the painter's early works were in circulation, and their authenticity cannot be accurately established. For example, in 2006 a version of Caravaggio's *Concert* from a Siennese collection was offered for auction in London. The original in the Metropolitan Museum in New York is in poor condition, but the better quality picture from Sienna is not considered to be by Caravaggio's own hand.

Nevertheless, it reached £100,000 at auction, which is a good price for a historical copy, but only a fraction of the value of an authentic Caravaggio.

Further clashes with the law

Caravaggio's short temper continued to get him into trouble. On 24 April 1604, a charge was brought by a certain Pietro da Fusaccia, a waiter in the Del Moro tavern. On the evening of that day, Caravaggio arrived to eat with two companions. He was brought a plate of artichokes and when he asked which had been cooked in oil and which in butter, the waiter replied that he should just use his nose. As noted in the records, Caravaggio's reaction was swift and decisive: "Without saying anything, he took an earthenware plate and flung it into my face. It hit me here, where I am injured, on the left cheek. Then he stood up and placed his hand on the sword of one of his companions, which was lying on the table, and got ready to strike me if I did not get up off the ground, and if I were to come here to make a charge." It did not take much to make Caravaggio lose his temper.

This was illustrated by yet another incident. At 5 in the morning on 18 November 1604, Caravaggio was stopped by a group of watchmen who were doing their rounds near the Trevi Fountain. As usual, the painter carried a sword and dagger on his belt. He complied with the request to show the registration certificate for his weapons; however, when the sergeant handed it back to him saying "Goodnight, sir," the over-sensitive ear of the artist thought he detected an ironic undertone and so he swore at the officer "in a very coarse way." The officer immediately arrested him and charged him with insulting an official. The painter

Michelangelo Merisi from Caravaggio, who was by now quite familiar with the legal system, had to serve his punishment in the jail at Tor di Nona—we do not know for how long.

Following this incident, Caravaggio's permit to carry a weapon was probably also revoked, for six months later, on 28 May 1605, near the church of San Ambrogio al Corso, he ran into the police captain of the Capitoline Curia, a certain Captain Pino, who asked him for his registration certificate; it turned out that he did not have one. Pino confiscated his sword and dagger and charged the artist with the possession of illegal weapons. This action was apparently unsuccessful, however, for just two months later Caravaggio drew a sword and injured the notary Mariano Pasqualone "on the head" (though probably with the handle of the sword, not the blade). According to the police files, on 29 July in the Piazza Navona, both men had got into a quarrel over a woman called Lena, the artist's lover. It appears that the notary made the woman a proposal of marriage that she rejected. Following this, the spurned suitor called her the "concubine of an accursed excommunicated man." The insulted painter became violent. The intervention of the French emissary had protected him from prison two years before, but it was now prudent not to remain in Rome and so he left for Genoa. He stayed there for approximately three weeks until the situation was resolved through the intervention of his noble patron. He returned to Rome on 26 August. In the meantime, Prudenzia Bruna, Caravaggio's landlady, had confiscated his possessions as security for his outstanding rent. Caravaggio, naturally, did not take this quietly. On the night of 31 August he appeared in front of

Bruna's house with his companions, ranting diabolically and singing satirical songs; a stone was thrown and a window broken. Charges were again brought against the artist, this time before the Governor. It is not known what compensation Caravaggio had to pay his landlady.

Murder

On the evening of 28 May 1606 in the Campus Martius in Rome, a quarrel occurred that had tragic repercussions for Caravaggio. He killed a man. This time even his relationships with influential friends did not help: he was sentenced to death. This event and its consequences would leave a deep imprint in Caravaggio's art.

According to a dispatch from the papal police to the authorities in Urbino, the course of events was roughly as follows: "On the above-mentioned Sunday evening, a brawl took place in the Campus Martius; four people were involved—Ranuccio da Terni at the head, who was left for dead after a prolonged disagreement. On the other side stood Michelangelo da Caravaggio, a painter who currently enjoys a certain fame; it is said that he was injured, though no one can say where he is. Although also seriously injured, one of his companions, whom they call Capitano Antonio da Bologna, a soldier from Castello, was also arrested. It is said that the cause of the disagreement was a wager of 10 scudi that the painter owed to the victim." According to the files, Caravaggio's "band" included two of his painter friends, Onorio Longhi and Mario Minniti. Ranuccio Tommasoni, the full name of the victim, died from loss of blood following the rupture of an artery in the leg caused by being beaten with a stick. The wager was on the result of a game of tennis.

In a letter dated 31 May 1606, Pellegrino Bertacchi, secretary of Cardinal Alessandro d'Este and later Bishop of Modena, suggested the less probable theory that the crime was only manslaughter, possibly even in self-defense. According to this version of events, the opposing team had unduly provoked the Lombard, who was known for his violent temper. The painter himself later gave this account of the incident when making his plea for clemency. However, it appears that there may have been more behind the deadly quarrel than just the outcome of a game of tennis. Tommasoni belonged to a family of thugs and disreputable bodyguards who were known throughout the city. There had often been disagreements and quarrels between him and Caravaggio. Tommasoni and Caravaggio were also rivals for the affection of the same woman, Fillide Meladroni; they moved in the same circles, had mutual betting debts, and this was probably not the first time that there had been violence between them. Political factors possibly also played a role. The Tommasonis were followers of the powerful aristocratic Crescenzi family, who were supporters of the Spanish, while Caravaggio had been committed to the French party headed by his patron, Cardinal Del Monte, since the commission for the Matthew Cycle for the Contarelli chapel in the church of San Luigi dei Francesi, the national church of France in Rome.

The Roman court immediately placed the painter on the wanted list and a trial was held without Caravaggio being present. He was sentenced to death by beheading, and whoever captured the fugitive had the right to carry out the sentence. Caravaggio was now a wanted man.

Caravaggio on the run

It is still not clear how the fugitive managed to escape from Rome. The protection of Prince Marzio Colonna certainly played an important role. It is not just that the prince harbored the painter at his estates in Lazio (in Zagarolo and Palestrina) and allowed his doctors to give him medical treatment. According to contemporary letters and dispatches, the prince also appears to have used his widespread network of family relationships (which stretched to Cardinal Borromeo in Milan) to create fake reports giving the impression that Caravaggio was on his way north, to Modena, Florence, or Genoa.

In fact, Caravaggio stayed hidden on the Colonna estate just a few kilometers from Rome and even painted two pictures for his protector, works he had possibly already started: the *Supper at Emmaus* in the Brera in Milan, and a Mary Magdalene whose appearance has been handed down in countless copies.

Caravaggio remained under Colonna's protection in Lazio for the whole of the summer of 1606. When he had fully recovered, he set off towards Naples in the south, in the opposite direction to that which the messages from northern Italy would have had the Roman authorities believe. He was also able to rely on the Colonna connections in Naples; they commended him to the relatives of an offshoot of the Carafa-Colonna family, who belonged to the highest levels of Neapolitan society.

A new beginning in Malta

After spending eight months in Naples, Caravaggio moved on. He boarded a ship that was bound for Marseille and then Malta, and that was under the command of the Admiral of the Maltese navy, Fabrizio Sforza Colonna, a son of the Marchese of Caravaggio and also a member of the far-flung and influential Colonna clan. The port register for Valletta records the arrival of the boat on 12 July 1607. The Maltese capital, home of the powerful Order of St. John (known as the Knights of Malta), which had branches across Europe and which crossed the Mediterranean with its warships, was effectively a fortress. This religious order of knights attracted the sons of the European nobility in search of overseas adventure and a life less ordinary. The Maltese considered themselves to be at the spearhead of the war against the Saracens and Barbary corsairs and maintained an elite aristocratic culture. Malta was the right place for a fugitive artist who wanted to erase his dark past. However, here too Caravaggio soon became known to the law courts, though initially only as a witness. On 26 July 1607, his statement was included in the records of a trial for bigamy. Caravaggio knew the accused well: it was Mario Minniti, his Sicilian painter friend who had been present at the fateful affray involving Caravaggio and Ranuccio Tommasoni in Rome that had cost Tommasoni his life and had almost cost Caravaggio his head.

However, the painter from Rome soon made the acquaintance of many aristocratic and influential personalities. Not long after his arrival he painted a portrait of the Grand Master of the Maltese Order, Alof de Wignacourt, in full armor and accompanied by a page. He also asked to be admitted to the Order and his request was granted after completion of the prescribed novitiate year. On 14 July 1608 he became a "cavaliere di grazia"— for a fugitive from justice who had been sentenced to death, this was an unexpected promotion, even if he was refused

the higher rank of "cavaliere di giustiza," which was retained for applicants from the aristocracy. This difference in rank had important consequences, as would soon become apparent.

After painting a St. Jerome for the main church of the Order, Caravaggio created one of his greatest works, *The Beheading of St. John the Baptist*. The man who had himself been condemned to death by the sword now signed the picture as a brother of the Order of St. John—"f. Michelango" (Fra Michelangelo)—in the martyr's blood.

During the late summer of 1608, events gathered pace. Full of resentment, Giovanni Pietro Bellori noted that "because of his tormented nature, he lost his prosperity and the support of the Grand Master. On account of an ill-considered quarrel with a noble knight of the Order he was jailed and reduced to a state of misery and fear. In order to free himself he was exposed to grave danger, but he managed to scale the prison wall at night. He fled unrecognized to Sicily with such speed that no-one could catch him." The exact details of Caravaggio's imprisonment no longer exist. It is highly probable that—possibly because he was provoked, perhaps also because he had been exposed as a criminal on the run—he had violently attacked and insulted one of the noble "cavaliere di giustizia."

Caravaggio escaped from the jail of Sant'Angelo, one of the heavily fortified bastions of the capital Valletta, on 6 October. In two decrees dated 1 November and 6 December 1608, it is stated that Caravaggio was excluded from the body of the Order as a "stinking, festering member." He returned to Naples.

Death on the beach

The last written testimony relating to a work by Caravaggio is dated 11 May 1610. On that day, his painting *The Martyrdom of St. Ursula*, which he had painted as a commission for the Genoese prince Marcantonio Doria, was shipped from Naples to Genoa.

Meanwhile, Caravaggio waited impatiently to be allowed to return to Rome. The moment came in July 1610: the attempts to win a papal pardon for the artist sentenced to death, who had now been on the run for four years, finally appeared to have been successful. For legal reasons, however, Caravaggio could not take the shorter overland route from Naples to Rome and so had to travel to the Papal State via the port of Porto Ercole. So he boarded a ship with several pictures in his luggage, including the *John the Baptist* that is today in the Galleria Borghese in Rome. On its way north along the coast of the Tyrrhenian Sea, the boat called at the small garrison port of Palo. For reasons still unknown, Caravaggio was arrested there; it was probably a case of mistaken, possibly due to the scar on his face that he had received in the tavern brawl in Naples. He was soon released, but the ship had sailed, taking all his luggage. Caravaggio possibly reached the beach at Porto Ercole on foot. What happened next can only be guessed at. Giovanni Baglione, Caravaggio's biographer and a rival, describes the last act in the life of his great rival with a telling lack of emotion: "In a miserable state of anxiety and desperation, he ran along the beach in the heat of the summer sun to see whether he could catch sight of the ship with his luggage. Arriving at Porto Ercole, he collapsed and was seized by a malignant fever that killed him miserably within

a few days without the aid of God or man. He died as miserably as he had lived."

Caravaggio died on 10 July 1610, probably following an attack of malaria, which had afflicted him since his childhood. He was thirty-nine years old. On 28 July, more than two weeks later, the news of his death reached Rome. Three days later it became known that Pope Paul V had already signed a pardon.

Caravaggio lost and found

Caravaggio is one of the most sought-after Old Masters in international exhibitions, his works always attracting thousands of visitors. It is thus understandable that the search for lost originals is carried out with great meticulousness throughout the world. Though the pieces that come to light do not always convince the experts, in the last few decades there have been spectacular new entries in the catalogue of his works. These include a number of works by the artist in small museums in the United States, for example: *The Cardsharps* in Fort Worth (Kimbell Art Museum), St. *Francis of Assisi in Ecstasy* in Hartford (Wadsworth Atheneum), *The Sacrifice of Isaac* in Princeton (Piasecka-Johnson Collection), *The Conversion of Mary Magdalene* in Detroit (Institute of Arts), and the *Martyrdom of St. Andrew* in Cleveland (Museum of Art).

The untiring efforts of Mina Gregori, the grande dame of Italian Caravaggio research, are to thank for the rediscovery of forgotten or poorly preserved works by the master, including a *St. Francis in Prayer* and the burlesque scene *The Toothpuller*. In addition, Mina Gregori has also significantly expanded our knowledge of Caravaggio's development as a portrait painter.

She also made finds in Britain and Ireland, unearthing two previously unknown works by the master. The art collection of the British royal family contained *The Calling of St. Peter and St. Andrew*, a work not identified as a genuine Caravaggio until it was restored in 2006. And in 1990 *The Taking of Christ* now in the National Gallery in Dublin was authenticated; prior to this only a historical copy in Odessa was known.

Further discoveries of this kind cannot be ruled out. As the case of *The Taking of Christ* in Dublin shows, if old copies of Caravaggio's paintings are well-documented, they can often allow researchers to draw conclusions on the fate and whereabouts of the original. Several such copies exist of a Caravaggio painting of a boy peeling fruit, which we know that the young artist probably painted in 1593 in Rome, though the original has not yet been identified conclusively. Research is divided over the question of the original *Penitent Magdalene*, as a very good copy by the Flemish painter Louis Finson exists.

On the other hand, there is no trace of the three paintings that during the war, like other works from the Berlin museums, were stored in a flak tower in Friedrichshain that went up flames in May 1945 (occasionally the theory is proposed that the pictures were not destroyed but taken to Russia in the confusion at the end of the war). There are old photographs of all three paintings; there was the original version of *St. Matthew and the Angel*, a very powerful version of *The Agony in the Garden*, and the *Portrait of Fillide Melandroni*.

Others are known to have been lost irretrievably. In particular the loss of *The Resurrection of Christ* that formerly hung in the church of Sant'Anna dei Lombardi in Naples,

weighs heavily, especially as there are no quality copies of the painting; it was destroyed (along with two other Caravaggios) in an earthquake in 1798. There are better prospects for new finds and attributions of Caravaggio's still-life paintings. In addition to the *Still Life with a Basket of Fruit*, other versions of the same subject have turned up that some experts consider authentic. In view of the fact that Caravaggio stayed in Malta for over a year, and that he generally painted very quickly, it can also be assumed that he did not limit his production to the two altarpieces for the cathedral, the *Sleeping Putto*, and portraits of Alof de Wignacourt and Antonio Martelli. It would, however, be much more difficult to track down one of the pictures that the young Michelangelo Merisi/Caravaggio had painted during his period in Milan before he traveled to Rome. Problems of quite a different type are connected with *The Adoration of the Shepherds with St. Lawrence and St. Francis*, which has been missing since 1969, when it was stolen from a small church in Palermo; there is regular speculation in the Italian press on its whereabouts and possible return.

Caravaggio and the Mafia

On 17 October 1969 it was pouring with rain in Palermo. Francesco Marino Mannoia and another henchman of the Mafia clan Dei Bontade took advantage of the bad weather and entered the church of San Lorenzo unnoticed by pushing open a window from a neighboring balcony. Using a ladder they climbed up the high altar and Mannoia cut the altarpiece from the frame using a razor blade, rolled it up and passed it down to his accomplice. They then absconded to Ponte dell'Ammiraglio on the outskirts of the city. The rain washed away the trail of flaked oil paint that they had left behind. No one noticed anything. And so *The Adoration of the Shepherds with St. Lawrence and St. Francis*, painted by Michelangelo Merisi da Caravaggio in 1609, disappeared. Only at three o'clock in the afternoon of the following day did the verger, Signora Maria Gelfo, make the shocking discovery that all that was left of Caravaggio's painting were a few shreds of canvas hanging in the frame. She called the police. Twelve hours had passed since the theft.

What happened during the next few days is even more amazing. The most important daily newspaper in Palermo started a survey of numerous intellectuals, professors, and

business people, the majority of whom admitted that they were unaware of the existence of a valuable painting of this kind in their hometown. The Mafia was obviously better informed. *The Adoration* was one of the few works by Caravaggio that was still in its original intended location. Caravaggio had painted it shortly before the end of his life in Palermo, the only work by him that could be viewed in the Sicilian capital. Now it had disappeared.

And it would disappear again. As Mannoia later said in his statement, he hid the prize under his bed for some time so that he could then deliver it to his buyer. The buyer was moved to tears when he saw the badly damaged masterpiece in front of him and refused to pay. For the hapless Mafioso, who was later a chief witness for the police, there was no other choice but to hide the canvas again. From now on, the statements contradict each other. Mannoia claims he threw the picture into the refuse (highly improbable: it should have been clear to even a petty thief such as Mannoia that an authentic Caravaggio would be worth a fortune). The wildest rumors abound about the actual whereabouts of the painting. Another Mafia star witness, Salvatore Cangemi, claims to have seen the picture in the collections of the top Mafia bosses, where it was suppos-

edly displayed as proof of the power of organized crime. Giovanni Brusca, the boss of the Cosa Nostra arrested in 1996, stated that he had offered to return the work of art to the State if the law that sentenced Mafia bosses to severe prison terms were to be revoked in a countermove. A British journalist, Peter Watson, claims that in 1980 the current owner of the picture contacted him and arranged a meeting for 23 October. This meeting never took place, however: on that day the Irpinia earthquake shook the whole region of Campania.

The Italian and international press often speculate on the missing work by Caravaggio and its supposed imminent return. Art historians comment on the hypothetical purchase price that the work would achieve and mention huge sums. The director of the Italian art theft investigation team, Fernando Musella, has said that because more than forty years have passed, nothing actually stands in the way of a return of the painting, for, from a legal point of view, the theft can no longer be prosecuted as a crime. So there is still a chance that a late, great work by Caravaggio might one day reappear.

Anthology

For me, a 'brave man' is one who understands his craft, just as a brave painter is one who understands well how to paint and imitate things according to nature.

Michelangelo Merisi, known as Caravaggio
Interrogation records for charge of slander
by Giovanni Baglione, dated 28 August 1603

There is also in Rome a certain Michelangelo from Caravaggio who creates wonderful things there. He came from poverty and has worked his way up in life by working hard, facing everything with courage, like those who do not want to be held back by despondency ... however, one must take the rough with the smooth, and with his volatile spirit he could not keep to his art: after two weeks of work he would wander around for two months, his rapier in his belt, a page by his side. He goes from one playing field to the next and is always making deals so that no-one wants to have anything to do with him. This is, however, totally contrary to our art, for Mars and Minerva were never friends with one another. However, his pictures are very pleasant and have a wonderful style, a proper example of the painter's youth.

Karel van Mander
Het Schilderboeck, 1604

Michelangelo Merisi [Caravaggio] was a satirical and proud man. At times he would speak badly of the painters from the past, and also from the present, no matter how distinguished they were, because he thought that he alone surpassed all the other artists in his profession. Moreover, some people thought that he had destroyed the art of painting; also, many young artists followed his example and painted heads from life, without studying the rudiments of design and the profundity of art, but were satisfied only with color. Therefore these painters were not able to put two figures together, nor could they illustrate a history, because they did not comprehend the value of so noble an art.

Giovanni Baglione
Le Vite de' pittori, scultori e architetti, 1642

In Rome, Caravaggio began to paint according to his own inclinations, not only ignoring but even despising the superb statuary of antiquity and the famous paintings of Raphael. He considered nature to be the only subject fit for his brush. As a result, when he was shown the most famous statues of Phidias and Glykon, in order that he might use them as models, his only answer was to point towards a crowd of people, saying that nature had given him an abundance of masters.

Giovanni Pietro Bellori
Vite de' pittori, scultori e architetti, 1672

Of all Italians, Caravaggio was the first to turn away his studies from the traditional old Mannerist methods and to focus on the naive imitation of nature according to life. For he endeavored to ensure that no stroke was different from real life and he kept the thing he wanted to paint in his room until he was sufficiently happy with the portrayal of nature in his work. So that he could also better portray the full curves and natural inclines, he diligently used vaults or other dark rooms that had only a little light from above so that darkness demonstrated its power over light by means of the strong shadows falling on the model and in this way created an elevated roundness.

Thus he despised everything that was not created as in real life and called the work trivial, childish and coarse because nothing could be better than that which is closest to nature. To be truthful, this is also not a bad route to perfection, for what appears in drawings and paintings, no matter how beautiful it may be, can never be as good as nature itself. Almost all Italian painters adopted his style.

Although his reputation is now considered deserving due to his great works of art, and he is now praised by many, he was very difficult to deal with. For he not only had little regard for the works by other Masters (though he also did not praise his own in public), he was also quarrelsome and displayed strange behavior, and was constantly in search of a fight.

Joachim von Sandrart
Teutsche Academie, 1675

He was however carried away by his somber genius, and represented objects with very little light, overcharging his pictures with shade. His figures inhabit dungeons, illuminated from above by only a single, melancholy ray. His backgrounds are always dark, and the actors are all placed in the same line, so that there is little perspective in his pictures; yet they enchant us, from the powerful effect that results from the strong contrast of light and shade. We must not look in him for correct design, or elegant proportion. For he ridiculed all artists who attempted a noble expression of countenance, or a graceful folding of drapery, or who imitated the forms of the antique, as exhibited in sculpture, his sense of the beautiful being derived entirely from visible nature.

Luigi Lanzi
Storia Pittorica dell' Italia, 1792–1796

Caravaggio's pictures are structured differently from those by the other painters of his time. For them, a picture was the sequence of a storyline or the portrayal of a thought. This means that all their elements are before our eyes within the picture area enclosed by the frame. In contrast, Caravaggio revealed only half of a figure, for example, his Paul in *The Conversion [of St. Paul]* in Santa Maria del Popolo, which is almost filled by the moon-lit body of the horse. This displacement of the section, these close-ups, mean that the individual figures are no longer seen as part of a story. Instead they are perceived as solid beings who

could step out of the picture at any moment to take someone's place, but equally who belong to their earthly reality and to transcendency, an ability that all pieces by the great artists have in our eyes. In Caravaggio's art, there is always something that reminds us of "outside of the picture," such as the uncertain darkness to which its chiaroscuro guides our eye and which is both oppressive and uplifting.

Yves Bonnefoy
L'image et le tableau dans la peinture du Seicento, 1989

Basing his art on the fundamental principle of painting direct from nature, to which no special feeling for the genre of portrait corresponded, the artist rebelled against the values of the great art of Rome. ... He rejected the idea of painting historical pictures out of his own imagination.

Anyone who makes painting as an act of reproducing into the guiding principle of his art will regard a still life as equal to the depiction of a human being. Caravaggio constructed his early pictures out of still lifes and models. He quickly grasped that landscape is not a field in which he could prove himself. With his very highly developed tactile sense, he explored the human body and became one of the greatest painters of the nude in the history of art. He attempted genre-painting direct from life and with full-length figures in only a few pictures. Yet, along with his sole authentic still life, he turned these into ground-breaking pioneer works of revolutionary impact. An even more important step was his radical decision to subjugate biblical history-painting to the principles of portrait and genre-

painting. Transformed into monumental paintings in a public church context, Caravaggio's redefinition of art met strong resistance. More than once, he was obliged to withdraw a first version, in order to fulfil the wishes of his patron, even though the circle of his patrons included the most progressive minds in Rome. With their support, Caravaggio also opened up new markets for painting. Half-length and full-length biblical history-paintings immediately found a place in royal galleries...

Eberhard König
Caravaggio, 1997

Genius, criminal, revolutionary artist, ascetic, bravo, dandy, murderer, rebel, sensualist, fugitive, mocker, lay brother. How could all these epithets be true of one man? In the year 1616, if one were to ask thoughtful and well-educated people to name the most influential geniuses of that age, the answer would certainly include Shakespeare and Cervantes, both of whom died that year. These two geniuses had closed the Elizabethan and Spanish Renaissance Golden Ages and changed literature ever after. It is not unlikely that many prescient persons in Rome would also have added the name of Caravaggio – already dead six years – to such a list. A true recipient of all the above epithets, it is certain now, nearly four centuries later, after a lapse where the later Rembrandt and Velásquez were better remembered, that Caravaggio was the singular artist who blazed into the Baroque Age and transformed the face of art for ever.

Patrick Hunt
Caravaggio 2004

His still life [*Still Life with a Basket of Fruit*] is another avowal of his belief in painting from nature and at the same time making his audience aware that they are looking at a painting. It is also [a] rebellious rejection and refutation of the months during which he toiled as the (no doubt underpaid) flower-and-fruit man in Cesari's studio.

Nearly every fruit in Caravaggio's basket looks as if it has spent too long on the vine or on the ground in the orchard. The pear is speckled with brown spots, the figs have begun to split, and no one has even bothered to turn the apple around so that the wormhole won't show in the painting. The leaves are in even worse condition, half-wilted and autumnal or disfigured by dry, discolored patches, frayed edges, and the ragged gnawings of insects. The water droplets sprinkled about only serve to make us aware that the fruit is anything but dewy or fresh.

Breughel's flowers seem to want to explode out of the painting, but Caravaggio's fruits rest heavily on the woven straw basket, each piece weighing on the other. Nothing, we'd think, could be more "real" than these decidedly unidealized fruits, and yet at the same time the artist is continually subverting our sense of reality. The grapevine on the right rises on a diagonal, countermanding the laws of gravity. The leaves and branches are attached to the fruits in ways we can't remember having seen. The only shadow in the painting is cast by the base of the basket, which hangs over the ledge on which it is set, and which seems to project into some disorientating dimension between us and the subject of the painting.

Francine Prose
Caravaggio: Painter of Miracles, 2005

Criticism from the circles of the Counter Reformation against the Mannerist painters and their works was certainly one of the reasons why Merisi so decisively turned away from the formal approach that was traditional in artistic work. Yet it was precisely these circles of the lower and middle clergy from whom he received the greatest resistance. They refused to place his pictures on their altars and in doing this could appeal to the voice of the people. One must remember that these problems and difficulties in understanding were also related to the general situation of art, which was in a general state of upheaval and uncertainty.

Mina Gregori
Caravaggio, 2006

Caravaggio's art is made from darkness and light. His pictures present spotlit moments of extreme and often agonized human experience. A man is decapitated in his bedchamber, blood spurting from a deep gash in his neck. A man is assassinated on the high altar of a church. A woman is shot in the stomach with a bow and arrow at point-blank range. Caravaggio's images freeze time but also seem to hover on the brink of their disappearance. Faces are brightly illuminated. Details emerge from darkness with such uncanny clarity that they might be hallucinations. Yet always the shadows encroach, the pools of blackness that threaten to obliterate all. Looking at his pictures is like looking at the world by flashes of lightning.

Caravaggio's life is like his art, a series of lightning flashes in the darkness of nights.

Andrew Graham-Dixon
Caravaggio: A Life Sacred and Profane, 2010

Locations

AUSTRIA
Vienna
Kunsthistorisches Museum
The Crowning with Thorns, c. 1603
Madonna of the Rosary, 1606–1607

BRITAIN
London
National Gallery
Supper at Emmaus, 1601

FRANCE
Paris
Musée du Louvre
The Fortune Teller, 1596–1597
The Death of the Virgin, 1605–1606

GERMANY
Berlin
Gemäldegalerie
Love Victorious, 1601–1602
Potsdam
Bildergalerie, Sanssouci
The Incredulity of St. Thomas, 1600–1601

IRELAND
Dublin
The National Gallery of Ireland
The Taking of Christ, 1602

ITALY
Florence
Fondazione Longhi
Boy Bitten by a Lizard, 1595–1596
Galleria Palatina, Palazzo Pitti
Portrait of a Knight of Malta, 1608–1609
Galleria degli Uffizi
Bacchus, 1596–1597
Medusa, c. 1597
The Sacrifice of Isaac, c. 1603
Genoa
Galleria Civica di Palazzo Rosso
Ecce Homo, 1605
Milan
Pinacoteca Ambrosiana
Still Life with a Basket of Fruit, 1597–1598
Pinacoteca di Brera
Supper at Emmaus, 1606
Messina
Museo Regionale
The Raising of Lazarus, 1608–1609
The Adoration of the Shepherds, 1609

Naples
Banca Intesa Collection
The Martyrdom of St. Ursula, 1610
Museo Nazionale di Capodimonte
The Flagellation of Christ, 1607
Pinacoteca del Pio Monte della Misericordia
The Seven Works of Mercy, 1606–1607
Rome
Galleria Borghese
Sick Bacchus, 1593–1594
Boy with a Basket of Fruit, 1593–1694
Madonna and Child with St. Anne (Madonna dei Palafrenieri), 1605–1606
St. Jerome, 1605–1606
John the Baptist, 1609–1610
David with the Head of Goliath, c. 1610
Musei Capitolini
The Fortune Teller, 1593–1594
John the Baptist, 1602
Galleria Corsini
John the Baptist, c. 1603–1604
Galleria Doria Pamphilj
The Penitent Magdalene, 1594–1595
Rest on the Flight into Egypt, 1595–1596

Galleria Nazionale d'Arte Antica
Judith Beheading Holophernes,
c. 1599
Balbi Odescalchi Collection
The Conversion of St. Paul, 1600–
1601
San Luigi dei Francesi
The Martyrdom of St. Matthew, 1599–
1600
The Calling of St. Matthew, 1599–
1600
The Inspiration of St. Matthew, 1602
Sant'Agostino
*Madonna of the Pilgrims (Madonna di
Loreto)*, c. 1604–1606
Santa Maria del Popolo
The Conversion of St. Paul, 1600–
1601
The Martyrdom of St. Peter, 1600–
1601
Musei Vaticani
The Entombment of Christ, 1602–
1604
Syracuse
Santa Lucia
The Burial of St. Lucy, 1608–1609

MALTA
Valletta
St. John's Co-Cathedral
*The Beheading of St. John the
Baptist*, 1608

RUSSIA
St. Petersburg
State Hermitage Museum
The Lute Player, 1595–1596

SPAIN
Madrid
Museo Nacional del Prado
David and Goliath, c. 1597–1598
Museo Thyssen-Bornemisza
St. Catherine of Alexandria, c. 1598–
1599

UNITED STATES
Cleveland
The Cleveland Museum of Art
The Martyrdom of St. Andrew, c. 1607
Detroit
Institute of Arts
The Conversion of Mary Magdalene,
c. 1598

Fort Worth
Kimbell Art Museum
The Cardsharps, c. 1594
Hartford
Wadsworth Atheneum
St. Francis of Assisi in Ecstasy,
1594–1595
New York
The Metropolitan Museum of Art
The Concert, c. 1595

Chronology

The following is a brief overview of the main events in the artist's life, plus the main historical and cultural events of the day (*in italics*).

1571
29 September: Michelangelo, the son of Fermo Merisi and Lucia Aratori, is born in Milan, where he is baptized in the parish church of Santo Stefano on the following day.
The Duchy of Milan is under Spanish rule. Archbishop Carlo Borromeo implements extensive reforms whose effects are felt in art, music, and architecture.
7 October: a Christian armada defeats the Ottoman fleet at the Battle of Lepanto.

1576
Titian dies in Venice.

1577
In Milan, the Great Plague rages.

20 October: Fermo Merisi, Caravaggio's father, dies of the plague; the family leaves Milan and moves to Caravaggio.

1584
At the age of 13, becomes an apprentice to the painter Simone Peterzano in Milan.
Archbishop Carlo Borromeo dies; in 1610 he is canonized by Paul V.

1592
After the death of his mother, the family inheritance is divided between the siblings. Moves to Rome.
Ippolito Aldobrandini become pope as Clement VIII.

1593–1595
His early years in Rome are not easy. Works as an assistant for various painters, including Giuseppe Cesari, known as the Cavalier d'Arpino.
The learned Cardinal Federico Borromeo, a cousin of Carlo Borromeo, and one of the first supporters of Caravaggio, becomes the Archbishop of Milan.
Clement VIII lifts the excommunication of Henry IV of France after he renounced Protestantism. With the rapprochement between France and the Holy See, sympathetically minded cardinals such as Franceso Francesco Maria Del Monte, Caravaggio's future patron, succeed to the Curia of France.

1596–1598
Moves to the household of Cardinal Francesco Maria Del Monte in the Palazzo Madama and gains access to the aristocratic art collections and collectors of Rome. His early pictures mainly show every day scenes.

1599–1600
Receives his first commission for a public location, the Contarelli chapel in the church of San Luigi dei Francesi. The first version of the altarpiece, *The Inspiration of St. Matthew*, is rejected; the final version is created in 1602, after the two side pictures (*The Calling of St. Matthew* and *The Martyrdom of St. Matthew*).
During the course of the Counter Reformation, the Church imposes conformity to its beliefs vigorously.
17 February 1600: astronomer Giordano Bruno is burned at the stake at Campo dei Fiori in Rome.

1600
Jacopo Peri completes Euridice *(one of the very first operas) for the wedding of Henry IV of France and Maria de' Medici in Florence.*

1601
Receives his second public commission: paintings for the side walls of the Cerasi chapel in the church of Santa Maria del Popolo (*Conversion of St. Paul*, and *Crucifixion of St. Peter*). The first version of the former is rejected. Yet he is still considered an established church painter. Over the next few years, four additional commissions for altarpieces will be granted.
A fleet sailing under the Spanish and Genoese flags attacks Algiers to drive out the corsairs based there, but the campaign is unsuccessful. Barbary

pirates still threaten Christian sea trade and are in battle with the Knights of Malta, among others.

1603
The painter Giovanni Baglione brings an action for slander against Caravaggio.
Around this time, Shakespeare writes Othello.

1604
24 April: a waiter, Pietro da Fusaccia, brings an action for assault against Caravaggio.
18 November: arrested for insulting an official.

1605
Injures the notary Mariano Pasqualone in a quarrel. Stays in Genoa for several weeks, where he makes contact with Prince Marcantonio Doria. From 1603 to 1605 Caravaggio, is mentioned a total of five times in the Roman police files on various charges.
Camillo Borghese becomes pope as Paul V.

1606
28 May: fatally injures Ranuccio Tommasoni in a brawl and receives serious injuries himself. Flees to the estates of the Colonna family in Lazio.

When sentenced to death in absentia, leaves for Naples (September).

1607
In Naples, receives several commissions for altarpieces.
12 July: arrives in Malta; a few days later makes a statement in a trial against his painter friend Mario Minniti, who is accused of bigamy.
Claudio Monteverdi composes his opera L'Orfeo for a court performance during carnival in Mantua.

1608
Meets the Grand Master of the Knights of Malta, Alof de Wignacourt, and paints his portrait as well as several altarpieces.
14 July: on completion of his novitiate year, is made a member of the Knights of Malta. In the fall, is imprisoned for offending another member of the Order and expelled. With the help of his friend Mario Minniti, in December manages to flee to Syracuse in Sicily.

1609
Stays in Sicily until the end of September. In Messina and Palermo, completes commissions for altarpieces. In October returns to

Naples and receives a serious injury to his face in a tavern brawl.
Peter Paul Rubens returns to Antwerp after several years in Italy. Annibale Carracci, the leading representative of classicism in painting, dies in Rome.

1610
18 July: dies on the beach at Porto Ercolo from an attack of malaria. Just ten days later, news of his death reaches Rome. Pope Paul V has already signed his pardon.
Claudio Monteverdi publishes his Vespers.

Literature

Early sources (17th-century texts):

Giulio Mancini, Giovanni Baglione, and Giovanni Bellori, *Lives of Caravaggio*, London 2005

Studies:

R. P. Hinks, *Michelangelo Merisi da Caravaggio: His Life, His Legend, His Works*, London 1953

Walter Friedlander, *Caravaggio Studies*, New York 1969

Howard Hibbard, *Caravaggio*, New York 1983

Mina Gregori, *The Age of Caravaggio, 1590–1610*, New York 1985

Alfred Moir, *Caravaggio*, New York 1989

Sergio Bernedetti, *Caravaggio: The Master Revealed*, Dublin 1993

Eberhard König, *Caravaggio*, Cologne 1997

Catherine Puglisi, *Caravaggio*, London 1998

Helen Langdon, *Caravaggio: A Life*, New York 1998

Rosa Giorgi, *Caravaggio: Master of Light and Dark*, London 1999

Gilles Lambert, *Caravaggio*, Munich and London 2000

Peter Robb, *M*, Sydney 2000 (original edition 1998)

John Spike, with Michèle Kahn Spike, *Caravaggio*, with a catalogue of paintings on a CD-ROM, New York 2001

Pietro Koch, *Caravaggio: The Painter of Blood and Darkness*, Rome 2004

Francine Prose, *Caravaggio: Painter of Miracles*, New York 2005

John Varriano, *Caravaggio: The Art of Realism*, University Park 2006

Andrew Graham-Dixon, *Caravaggio: A Life Sacred and Profane*, London 2009

Sebastian Schütze, *Caravaggio: The Complete Works*, Cologne 2009

Michael Fried, *The Moment of Caravaggio*, Princeton 2010

David Franklin and Sebastian Schutze, *Caravaggio and His Circle in Rome: A Barbaric and Brutal Manner*, New Haven 2011

Picture Credits